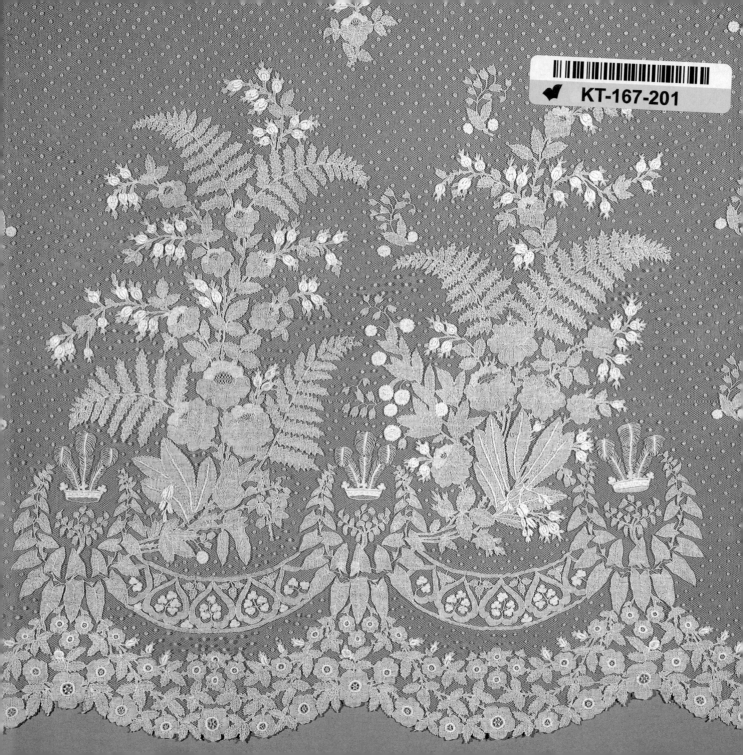

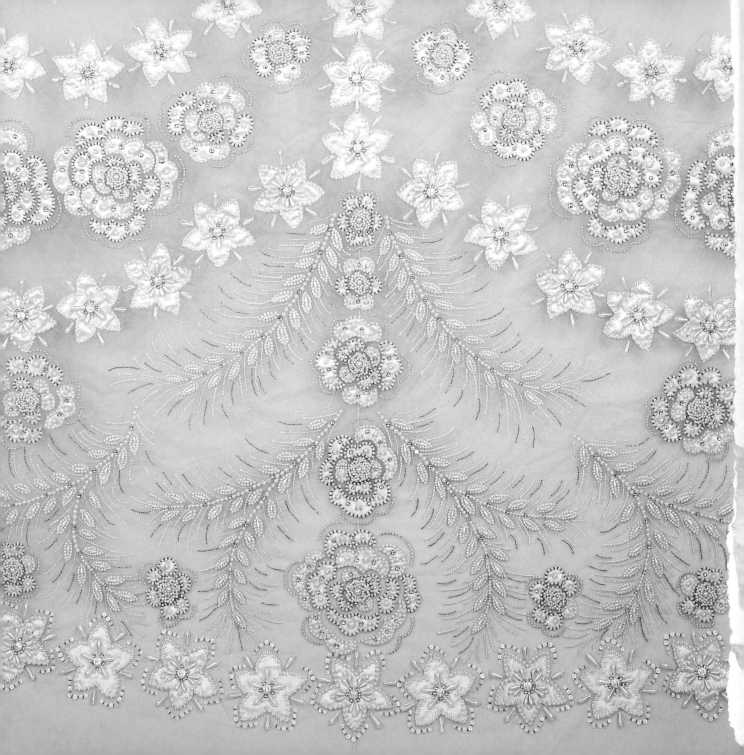

# FIVE GOLD RINGS
## A ROYAL WEDDING SOUVENIR ALBUM
### FROM QUEEN VICTORIA TO QUEEN ELIZABETH II

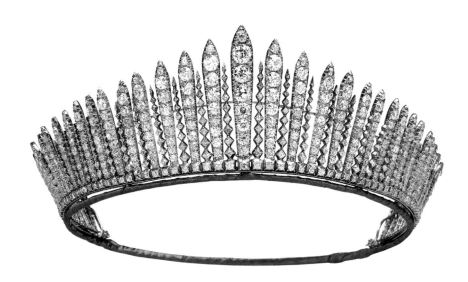

ROYAL COLLECTION PUBLICATIONS

Published by Royal Collection Enterprises Ltd
St James's Palace, London SW1A 1JR

For a complete catalogue of current publications, please write to the address above,
or visit our website on www.royalcollection.org.uk

154591

ISBN 978 1 902163 71 0

British Library Cataloguing in Publication Data:
A catalogue record for this book is available from the British Library.

Compiled by Jane Roberts and Sabrina Mackenzie
Designed by Peter Drew of Phrogg Design
Typeset in Garamond
Printed and bound by Studio Fasoli, Verona
Printed on Symbol Tatami White, Fedrigoni Cartiere Spa, Verona
Production by Debbie Wayment

Endpapers:
Veil of Carrickmacross lace made for the wedding of Princess Alexandra, 1863
(detail; RCIN 120013)

Frontispiece:
Princess Elizabeth's wedding train, designed by Norman Hartnell, 1947
(detail; RCIN 100020)

Title page:
Russian fringe tiara, made by E. Wolff & Co. for Garrards, 1919 (RCIN 200184)

This page:
Silk favour ribbon made to celebrate the marriage of Queen Victoria and
Prince Albert, 1840 (detail; RCIN 52494)

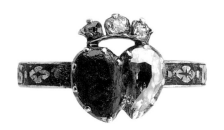

THE FIVE WEDDINGS featured in this book took place between 1840 and 1947. On each occasion, one of the parties was – or was later to become – Sovereign of the United Kingdom. Queen Victoria had ascended the throne three years before her marriage in 1840. Her son, the Prince of Wales, was still heir apparent at the time of his wedding in 1863 and would have to wait nearly forty years before succeeding to the throne. The Prince's only surviving son, the future King George V, married in 1893, became Prince of Wales following his father's accession in 1901, and came to the throne in 1910. George V's second son, the future King George VI, who married in 1923, came to the throne unexpectedly in 1936, following the abdication of his elder brother, King Edward VIII. Princess Elizabeth was heir presumptive when she married in 1947, her reign commencing five years later, in 1953.

In the brief account of the five weddings given in the following pages, the various changes in the celebration of royal marriages will become clear. Among these is the perception of a royal wedding as a national celebration, rather than the private occasion in 1840 with which our story begins. With the growth of photography in the years that followed, it was possible for increasing numbers to view the wedding celebrations. And the photographic and cinematographic records of the crowds between Westminster Abbey and Buckingham Palace in both 1923 and 1947 show how keenly watched, and celebrated, were both those occasions.

In 1863 the wedding of the future King Edward VII was celebrated at St George's Chapel, Windsor Castle. Most previous royal weddings had taken place in London, in the relative privacy of the Chapel Royal, St James's Palace, or occasionally in a room of a royal residence. The choice of Windsor for the Prince of Wales's wedding resulted from Prince Albert's death there only two years before, and was driven by Queen Victoria's desire not to appear in public in London. For the marriage of the Prince of Wales's son, the future King George V, there was a return to the Chapel Royal. But by the time of his son's marriage in 1923, and of his granddaughter's marriage in 1947, it was clear that a larger setting would be required. Westminster Abbey – the traditional location of the coronation service – was therefore used for both of these weddings.

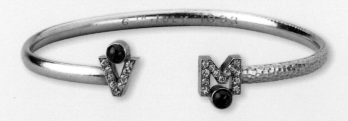

With the increased public interest and participation in royal weddings came the growth in the custom of present-giving – not only from close family and friends, but also from national institutions, and from individuals throughout the nation and Empire who had no personal acquaintance with the bride or groom. Queen Victoria's surprise at the quantities of presents which she received – from all over the world – at the time of her Golden Jubilee in 1887, compared with the relative paucity of wedding presents sent to her in 1840, was

a symptom of this change. In addition, the huge growth in technological and scientific development over the last century has led to a change in the choice of appropriate presents. In the early years these would have been personal and individual, but by 1947 they had become more practical and functional, and were often mass-produced.

However, a continuing theme has been the gift of spectacular jewellery to royal brides. Such gifts from close family members might involve historic jewels that had been passed down through the family over many generations, or newly made pieces.

The dresses worn by royal brides have inevitably reflected the changes in contemporary fashion. In 1840 Queen Victoria chose a plain court dress, with an orange-blossom circlet in her hair. The dresses of later royal brides have usually incorporated

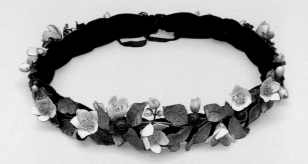

rather more of the 'dazzle' factor, for the royal bride must be strikingly visible. But in many respects it is the extraordinarily fine royal wedding lace that sets the royal bride's appearance apart from her contemporaries. The richly patterned lace worn by Queen Victoria in 1840, and by Princess Alexandra in 1863, was paralleled in 1947 by the spectacular star-patterned lace made for Princess Elizabeth.

The festivities surrounding a royal wedding include a so-called Wedding Breakfast (which usually takes place in the early afternoon) immediately after the religious ceremony. On an evening shortly before the wedding there might also be a ball, preceded by dinner. Invitations, menu cards, even remains of wedding cakes and cake decorations, have survived from all of the weddings featured here. Other mementoes include wedding favours, worn by members of the public to celebrate these happy occasions.

As the British Sovereign is also Head of the Church of England, royal weddings have an added significance. The events lying behind the birth of the first of our royal brides – Queen Victoria – and the circumstances which led to King Edward VIII's abdication

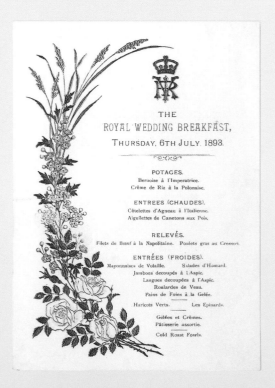

THE
ROYAL WEDDING BREAKFAST,
THURSDAY, 6TH JULY, 1893.

POTAGES.
Bernoise à l'Imperatrice.
Crème de Riz à la Polonaise.

ENTREES (CHAUDES).
Côtelettes d'Agneau à l'Italienne.
Aiguillettes de Canetons aux Pois.

RELEVÉS.
Filets de Bœuf à la Napolitaine.    Poulets gras au Cresson.

ENTRÉES (FROIDES).
Mayonnaises de Volaille.        Salades d'Homard.
Jambons decoupés à l'Aspic.
Langues decoupées à l'Aspic.
Roulardes de Veau.
Pains de Foies à la Gelée.

Haricots Verts.        Les Epinards.

Gelées et Crêmes.
Pâtisserie assortie.
Cold Roast Fowls.

in 1936, clearly demonstrate the importance of marriage and succession to the British monarchical system. Although George III and Queen Charlotte had fifteen children, in November 1817 their only grandchild – Princess Charlotte of Wales – died in childbirth leaving the blind and demented 79-year-old George III without an obvious heir in the generation after his own sons. The Prince Regent's younger brothers therefore hastened to find appropriate brides and to secure the succession. Over the following two years a positive flurry of royal weddings took place. Of these, only the issue of the fourth son, Prince Edward, Duke of Kent, is of direct relevance to our story. In mid-1818 the Duke married the widowed Princess of Leiningen, born Princess Victoria of Saxe-Coburg-Saalfeld, who on 24 May 1819 gave birth to a girl. According to the British principles of succession, based on male primogeniture, this child – Victoria – succeeded her uncle William IV in 1837.

Victoria (1819-1901) **QUEEN VICTORIA** = 1840 Albert of Saxe-Coburg and Gotha (1819-1861) PRINCE ALBERT

Albert Edward, Prince of Wales (1841-1910) **KING EDWARD VII** = 1863 Alexandra of Denmark (1844-1925) QUEEN ALEXANDRA

George, Duke of York (1865-1936) **KING GEORGE V** = 1893 Victoria Mary of Teck (1867-1953) QUEEN MARY

Elizabeth Bowes Lyon (1900-2002) QUEEN ELIZABETH, THE QUEEN MOTHER = 1923 Albert, Duke of York (1895-1952) **KING GEORGE VI**

Philip Mountbatten (b.1921) PRINCE PHILIP, DUKE OF EDINBURGH = 1947 Princess Elizabeth (b.1926) **QUEEN ELIZABETH II**

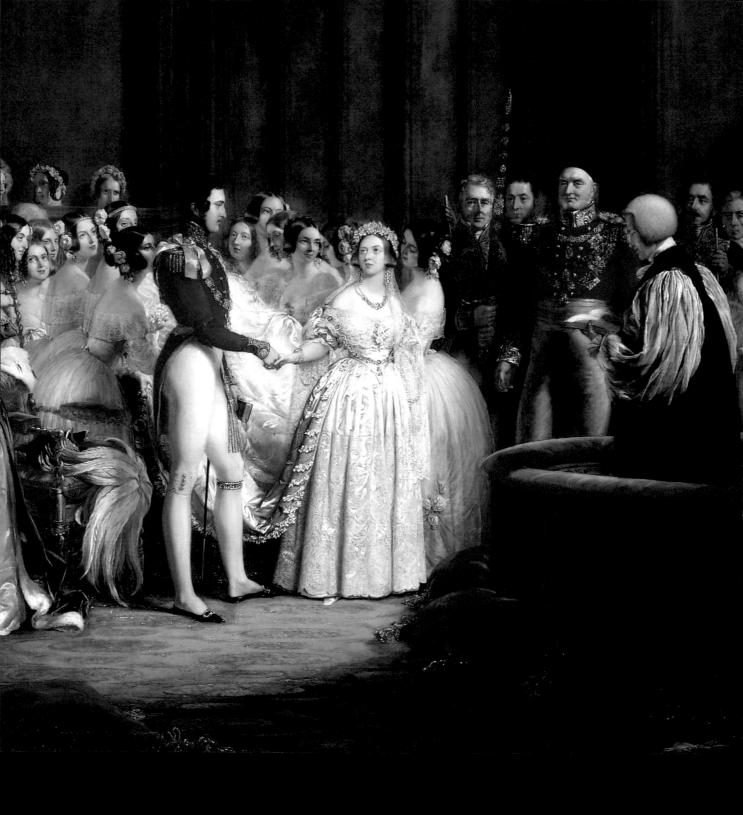

# VICTORIA
## AND
## ALBERT

## 10 FEBRUARY 1840

Queen Victoria was born at Kensington
Palace on 24 May 1819. Her father, Prince
Edward, Duke of Kent, was the fourth son of
King George III. Her mother was Princess
Victoria of Saxe-Coburg-Saalfeld (the widow
of the reigning Prince of Leiningen) who had
married the Duke of Kent in 1818.

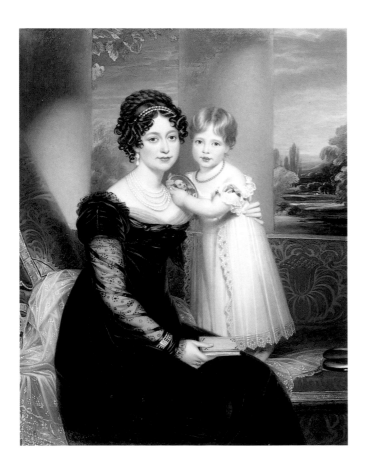

In Beechey's painting of 1821 the little
Princess clutches a miniature portrait of her
father (who had died in January 1820), while
being held affectionately by her mother.
The portrait was painted at Kensington Palace
for the Duchess's brother, Prince Leopold
(later King Leopold I of the Belgians), who
provided generously for the Duchess and
her daughter after the Duke's death.

The 18-year-old Princess succeeded to the throne on the death of her uncle, King William IV. She held her Accession Council at Kensington Palace on the morning of 20 June 1837, a few hours after the start of the new reign. The artist Sir David Wilkie sketched the young Queen in preparation for his painting of that historic Council meeting.

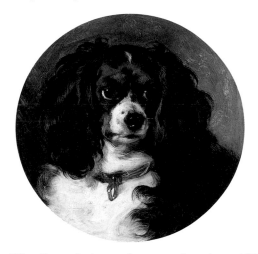

The Queen's devoted companion since 1833 – her spaniel, Dash – sits at her feet. Landseer's portrait of Dash was a birthday present from the Duchess of Kent to Princess Victoria in 1836.

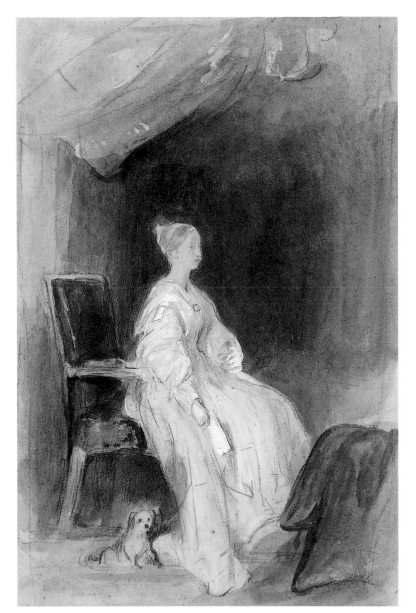

Prince Albert of Saxe-Coburg and Gotha was born at the small ducal residence of the Rosenau, near Coburg, on 26 August 1819. He was the second son of Louise (daughter and heiress of Augustus, Duke of Saxe-Gotha), and Ernest of Saxe-Coburg-Saalfeld, later Duke Ernest I of Saxe-Coburg and Gotha; his parents divorced in 1826. Ernest I's brother was Prince Leopold and his sister was Victoria, Duchess of Kent.

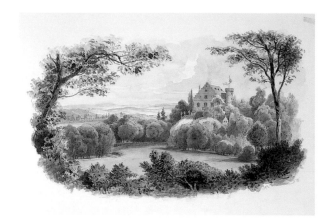

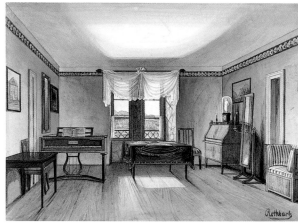

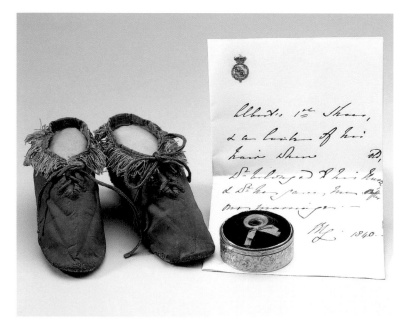

In 1840 Prince Albert's nurse gave Queen Victoria his first pair of shoes, and a lock of his hair.

Prince Albert and his elder brother Ernest – shown with a pet rabbit in 1829 – were educated together, first at Coburg, then in Brussels, and finally at Bonn University. The unchanged appearance of their first schoolroom at the Rosenau (opposite, centre left) was recorded for Queen Victoria in 1845.

In 1836 Ernest I brought his two sons to England to meet their cousin Victoria at the time of her seventeenth birthday. On 26 June 1837, six days after the Queen's accession, Prince Albert wrote to congratulate his cousin on her new position.

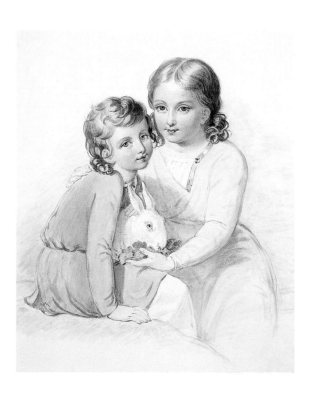

A marriage between Victoria and Albert had been a favourite scheme of their grandmother and was later vigorously pursued by their Uncle Leopold. Towards the end of his life, Prince Albert said that he had known since he was 3 that he was to marry his English cousin.

The Prince visited England for a second time in 1839, and on 15 October – only five days after his arrival – the Queen recorded in her Journal that she had asked 'if he would consent to what I wished (to marry me); we embraced each other over and over again, and he was <u>so</u> kind, <u>so</u> affectionate; Oh! To feel I was, and am, loved by <u>such</u> an Angel as Albert, was <u>too</u> <u>great</u> <u>delight</u> to describe! He is <u>perfection</u>; perfection in every way, – in beauty – in everything!'

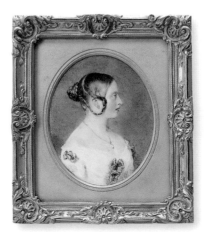

Before the end of October 1839 the royal miniaturist William Ross had begun work on a portrait of Prince Albert, which the Queen considered 'very like'. She had been struck by both the character and the appearance of the Prince, who was 'so excessively handsome, such beautiful blue eyes, an exquisite nose, and such a pretty mouth, with delicate moustachios, and slight but very slight whiskers; a beautiful figure, broad in the shoulders and a fine waist'. The companion portrait of the Queen was commissioned soon after.

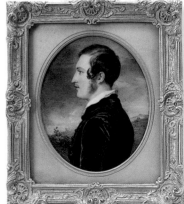

On Saturday 23 November, Queen Victoria
made this declaration to the Privy Council to
announce her engagement.

*Declaration*
*I the Privy Council*
*Saturday Nov: 23 – 1839.*

*I have caused you to be summoned at the present time in order that I may acquaint you with my resolution in a matter, which deeply concerns the welfare of my People and the happiness of my future life.*

*It is my intention to ally myself in marriage with the Prince Albert of Saxe Coburg and Gotha.*

*Deeply impressed with the solemnity of the Engagement, which*

*which I am about to contract I have not come to this decision without mature consideration nor without feeling a strong assurance that with the blessing of Almighty God it will at once secure my domestic felicity and serve the Interests of my Country.*

*I have thought fit to make this resolution known to you at the earliest period, in order that you may be fully apprised*

*apprised of a matter so highly important to me and to my Kingdom, and which I persuade myself will be most acceptable to all my loving Subjects.*

On the same day the Duchess of Kent gave
her daughter this gold bracelet with
conjoined amethyst hearts.

For much of the seventeen weeks of their engagement Prince Albert was in Coburg arranging his affairs before returning to England. A steady stream of letters and gifts were exchanged between the engaged couple. On 28 November the Queen had received 'a lovely brooch, – an orange flower', designed by Prince Albert.

The Prince – a skilled musical performer and composer – presented Queen Victoria with copies of his musical compositions. These included *Dem Fernen* ('Of distant lands') and *Der Orangenzweig* ('The orange twig'), written at Gotha on the last day of 1839.

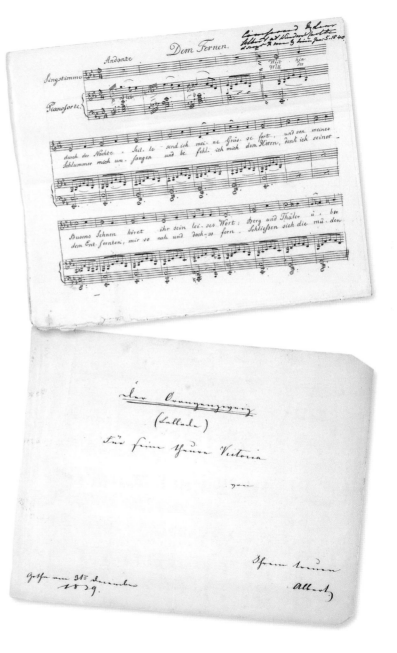

Three days before, Prince Albert had sent Queen Victoria a tiny gilded New Year token.

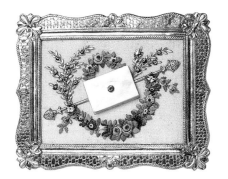

A month later he set off on his journey to England, visiting his Uncle Leopold in Brussels en route. The Prince brought with him a number of items from the ducal collections in Coburg and Gotha – including this mid-eighteenth-century German fan, which he gave to Queen Victoria on the day before their wedding.

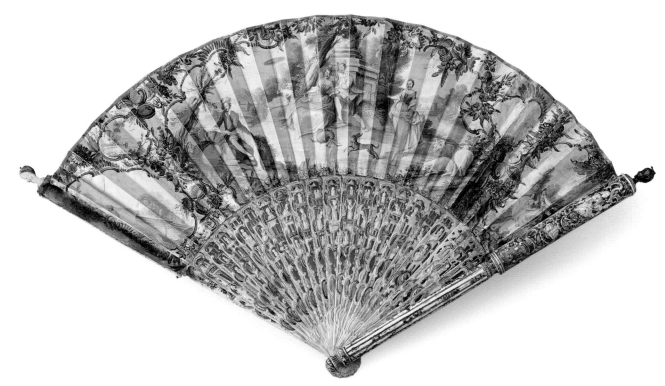

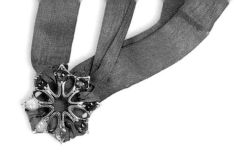

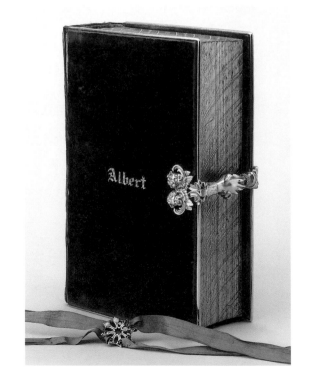

A velvet-covered prayer book was given to Prince Albert by his aunt and mother-in-law, the Duchess of Kent, on his wedding day. The decorated bookmark incorporates a circlet set with semi-precious stones, the initial letters of which spell VICTORIA.

On the same day – 9 February 1840 – Queen Victoria presented this diamond-studded Garter to Prince Albert. He had been invested as a Garter Knight in Germany shortly before his final departure for England. Queen Victoria was Sovereign of the Order, and Garter insignia were worn by both the bride and the groom at the wedding service.

Queen Victoria was attended by twelve
train-bearers – all daughters of peers of the
realm. Their costume was indicated in the
Queen's watercolour sketch, given to the
Duchess of Sutherland, the Mistress of the
Robes. On the day of the wedding, the
Queen recorded her first sight of the twelve
young girls, 'dressed all in white with white
roses, which had a beautiful effect'.

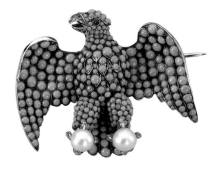

Each girl received one of these eagle brooches,
designed by Prince Albert. On a silver core,
the bird's body was set with turquoises and
pearls (to represent true love), a ruby (for
passion) and diamonds (for eternity).

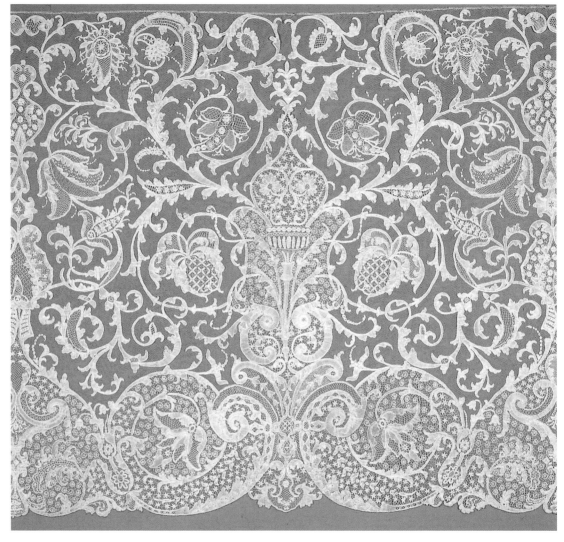

The lace flounce worn by Queen Victoria over the skirt of her wedding dress was made in Honiton. It was one of the Queen's most treasured possessions and was worn again at the weddings of her eldest child, Vicky, in 1858, and of her grandson, the future King George V, in 1893. Her youngest child, Beatrice, was permitted to wear the flounce at her wedding in 1885.

On the morning of her wedding day Queen Victoria made this sketch and noted in her Journal that she had her hair dressed 'and the wreath of orange flowers put on. My wreath & veil were thus worn:  saw my precious Albert for the <u>last</u> time <u>alone</u> as my <u>Bridegroom</u>. Dressed. I wore my Turkish diamond necklace and earrings, and my Angel's beautiful saphire broach.' The dress was made of Spitalfields silk. The sapphire and diamond brooch had been given to the Queen by Prince Albert on the day before the wedding.

Queen Victoria's appearance is recorded in Winterhalter's painting, commissioned as a wedding anniversary gift for Prince Albert in 1847.

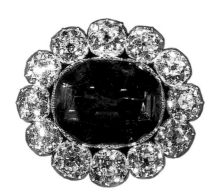

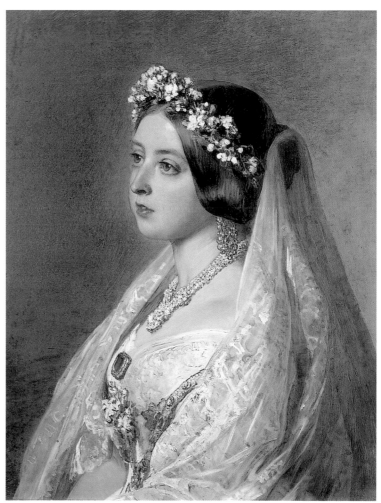

Queen Victoria's wedding to Prince Albert took place in the Chapel Royal, St James's Palace, on 10 February 1840, and was recorded in Hayter's painting, commissioned by the Queen. Pieces of the splendid Chapel Plate, including this silver candlestick made for George I in 1717-18, were displayed on the altar. This was the first wedding of a reigning Queen in England since 1554.

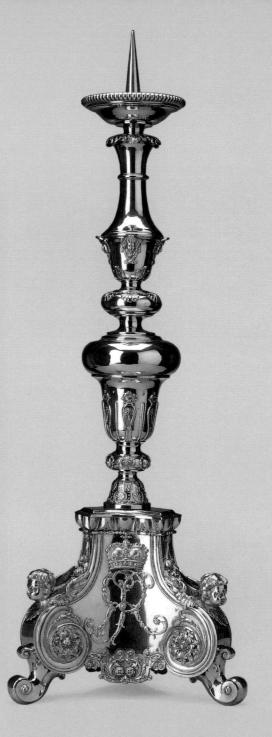

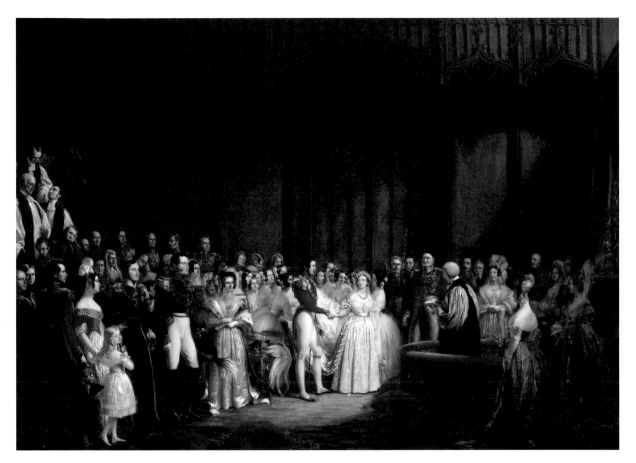

The Queen recorded that as she entered the Chapel 'The Flourish of Trumpets ceased … and the organ began to play, which had a beautiful effect. At the Altar, to my right, stood my precious Angel …The Ceremony was very imposing, and fine and simple, and I think <u>ought</u> to make an everlasting impression on every one who promises at the Altar to <u>keep</u> what he or she promises. Dearest Albert repeated everything very distinctly. I felt so happy when the ring was put on, and by my precious Albert.' The service was conducted by the Archbishop of Canterbury, who had suggested that the Queen might wish the word 'obey' to be deleted from her responses. She requested that it be retained.

The bride and groom emerged from the Chapel to loud applause from the waiting crowds. The Marriage Register was signed before the royal party left St James's for Buckingham Palace. The Queen recorded that those lining the route 'cheered us really most warmly and heartily; the crowd was immense'.

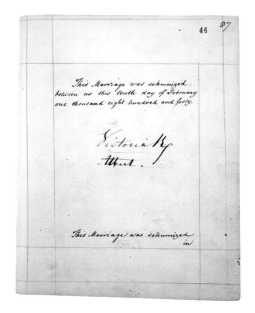

This Marriage was solemnized between us this tenth day of February one thousand eight hundred and forty.

Victoria R

Albert.

This Marriage was solemnized in

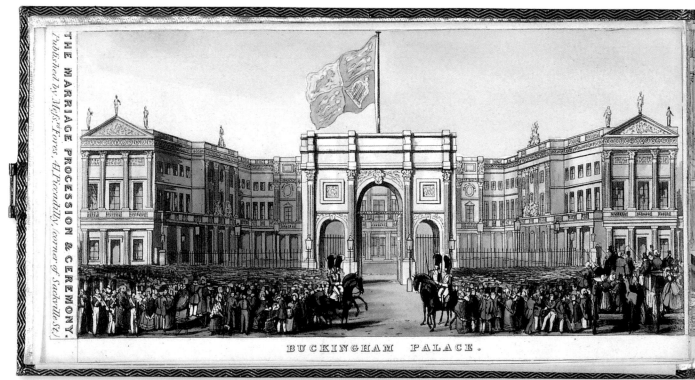

THE MARRIAGE PROCESSION & CEREMONY.
Published by Messrs Fores, 41 Piccadilly, (corner of Sackville St.)

BUCKINGHAM PALACE.

Coloured admission cards were issued to permit approved persons to watch the procession at St James's Palace. Members of the Queen's family and household were issued with carriage passes for Buckingham Palace.

A number of popular prints and panoramas were produced as souvenirs.

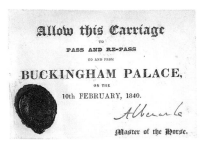

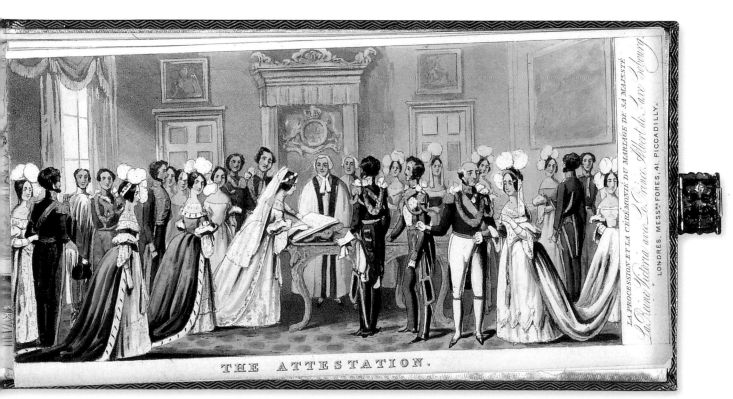

THE ATTESTATION.

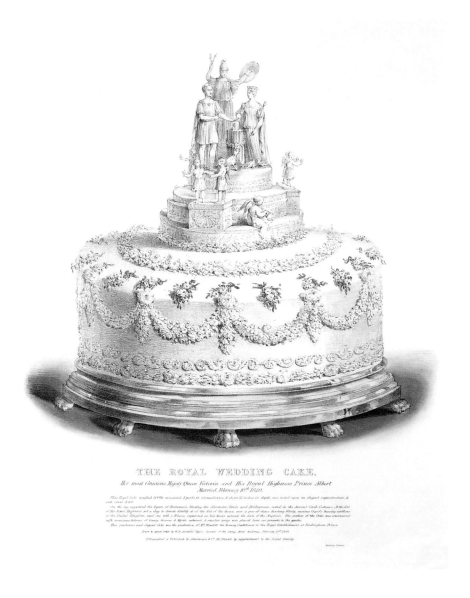

After the newly married couple had spent a half-hour alone together in the Queen's dressing room at Buckingham Palace, they rejoined their guests for the Wedding Breakfast in the State Dining Room – 'dearest Albert leading me in'. To ensure that there was enough wedding cake for both the guests and the many people to whom it was traditionally distributed, more than one cake was supplied. One of these was over 9 feet (about 3m) in circumference and weighed more than 300 pounds (about 140kg); it incorporated allegorical figures of the bride and groom.

Another cake bore shields decorated with the coats of arms of the bride and groom, made of icing sugar. Remarkably, these have survived, although in a rather damaged state.

Pieces of cake were packaged for distribution in various ways: both silver and cardboard containers were used.

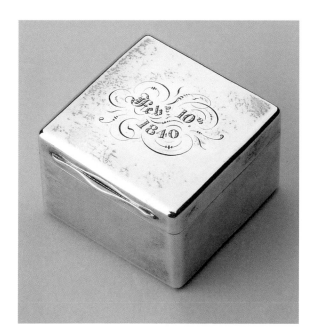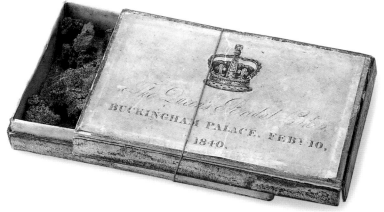

The Queen recorded in her Journal that after the Wedding Breakfast 'I went upstairs and undressed and put on a white silk gown trimmed with swansdown, and a bonnet with orange flowers.' The couple then departed for Windsor where the honeymoon was to be spent. After dinner, 'My dearest dearest dear Albert sat on a footstool by my side and his excessive love and affection gave me feelings of heavenly love and happiness, I never could have hoped to have felt before! …Oh! This was the happiest day of my life!'

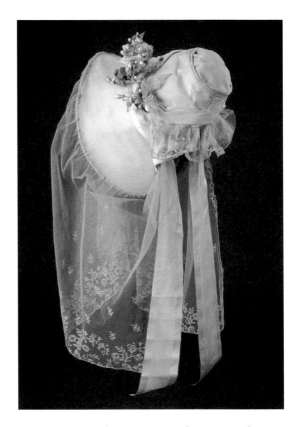

Queen Victoria's going-away bonnet is shown above. Her portrait of Prince Albert dates from the early years of their marriage, and records the blue eyes that she particularly admired.

On the morning of 13 February the Queen recorded: 'Got up at 20 m. to 9. My dearest Albert put on my stockings for me. I went in and saw him shave; a great delight for me.'

The honeymoon was spent walking, riding, singing, reading, or looking at pictures. The royal couple's delight in Windsor, and in their shared interests there, is recorded in Landseer's painting *Windsor Castle in Modern Times*, painted between 1841 and 1845.

Queen Victoria and Prince Albert had nine children, but the Prince died in 1861, after twenty-one years of marriage. Queen Victoria outlived the Prince by forty years, and on her death in 1901 she was succeeded by their eldest son, Albert Edward, Prince of Wales.

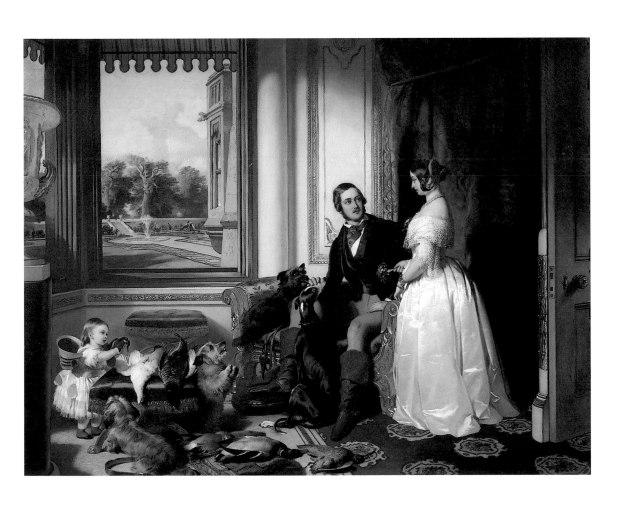

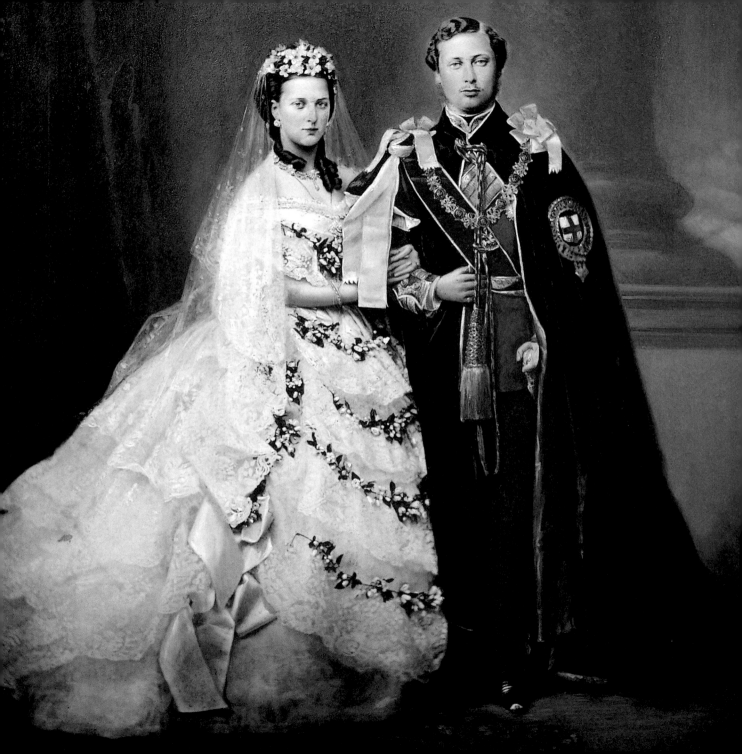

# ALEXANDRA
## AND
# EDWARD

# 10 MARCH 1863

Princess Alexandra was born in Copenhagen on 1 December 1844. She was the second child and eldest daughter of Prince and Princess Christian of Schleswig-Holstein-Sonderburg-Glücksburg. Her birthplace and first childhood home was the Yellow Palace, close to Amalienborg in Copenhagen.

By a series of complicated moves Prince Christian was in 1852 nominated as heir to the Danish throne. Thereafter his family moved to Bernstorff (below), a large house within extensive parkland near Copenhagen.

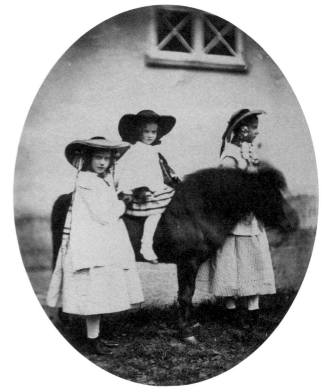

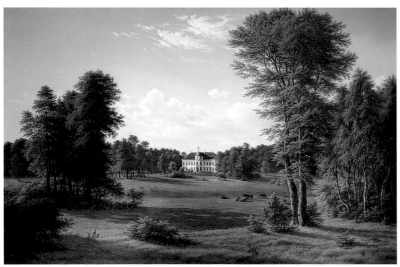

The Princess was photographed in 1856 with her two younger sisters, Dagmar and Thyra. Dagmar, the middle sister (on the left here) was to become the wife of Alexander III, the Tsar of Russia. Princess Alexandra stands by their pony's head.

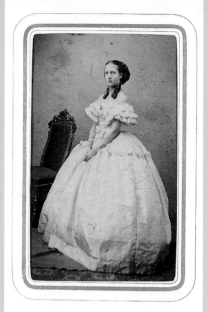

In October 1860 the 15-year-old Princess was confirmed. She had become an elegant and attractive young girl, noted for her cheerfulness and optimism. The first photographs of Princess Alexandra alone appear to date from around this time.

On the death of his kinsman in November 1863, Prince Christian succeeded as King Christian IX of Denmark. This page, with photographs of her parents, is taken from one of Alexandra's photograph albums at Windsor.

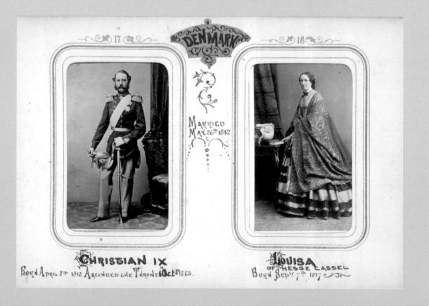

Prince Albert Edward (known to his family as Bertie) was born at Buckingham Palace on 9 November 1841. He was the second child and eldest son of Queen Victoria and Prince Albert. From birth he held the title of Duke of Cornwall and when one month old was named Prince of Wales. At the age of 2 the little Prince was portrayed by Winterhalter.

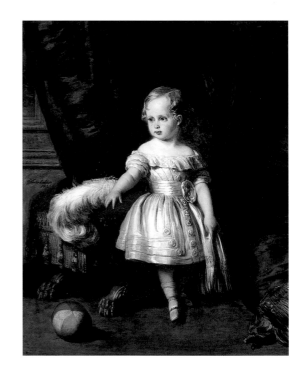

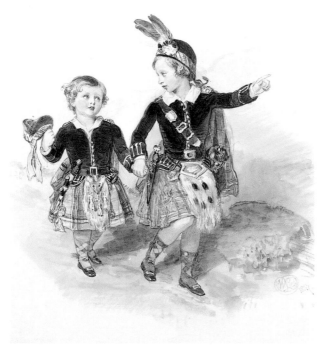

Four years later he was shown by Sir William Ross with his younger brother Prince Alfred. The outfits of Royal Stewart and Dress Stewart tartan were purchased shortly before the sitting.

The Prince of Wales's education was carefully supervised by his parents. In November 1858, at the age of 17, he was appointed a Knight of the Garter and gazetted Lieutenant Colonel in the British army. Winterhalter's portrait was painted in the following year.

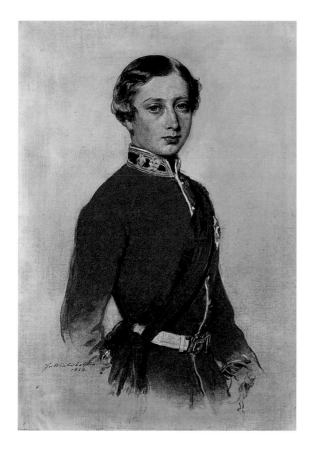

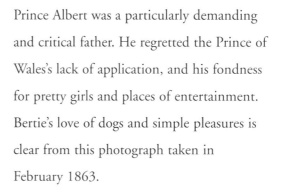

Prince Albert was a particularly demanding and critical father. He regretted the Prince of Wales's lack of application, and his fondness for pretty girls and places of entertainment. Bertie's love of dogs and simple pleasures is clear from this photograph taken in February 1863.

By 1860 the choice of a suitable bride for the Prince of Wales had become a serious concern. His elder sister Vicky (now married and living in Berlin) sent a very favourable report on Princess Alexandra. Photographs of the Princess were despatched to England and were much admired by both Queen Victoria and Prince Albert.

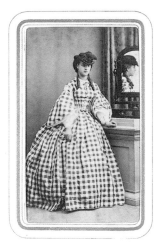

The Prince of Wales met Princess Alexandra for the first time in September 1861. Although the couple's mutual attraction was obvious, it was nearly a year before they met again – owing to the death of the Prince's father in December 1861. After this second meeting they became engaged – at Laeken, the home of Victoria and Albert's Uncle Leopold, on 9 September 1862. A number of engagement photographs were taken in Brussels. Soon after, the Prince wrote to Queen Victoria to express his great happiness (right).

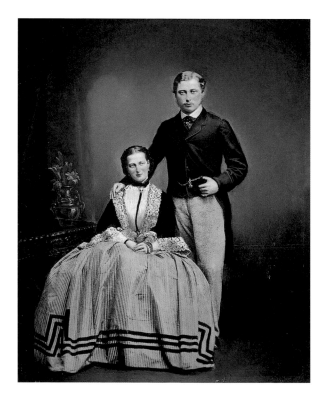

In November 1862 Princess Alexandra, accompanied by her father, visited England as the guest of Queen Victoria. In addition to making a pencil sketch of Alexandra, the Queen commented that she had 'plenty of sense and intelligence, and is, though very cheerful and merry, a serious solid character not at all despising enjoyments and amusements but loving her home and quiet – all much more'.

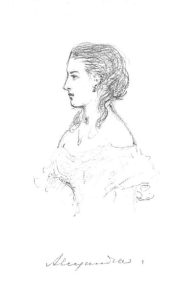

The Prince carefully preserved the red roses given to him by his fiancée on the day of their engagement.

Immediately after the announcement of the royal engagement, presents began to arrive. These were first displayed privately at Windsor, and then publicly at the South Kensington Museum. This fan was sent by Queen Victoria's half-sister Feodora. King Leopold I sent a suite of Brussels lace, including this lappet.

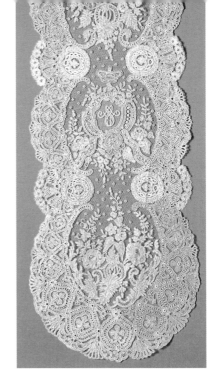

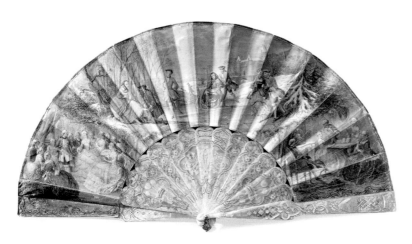

The jewellery given to Princess Alexandra included the 'Dagmar necklace', commissioned by King Frederick VII of Denmark and comprising 118 pearls and 2,000 diamonds.

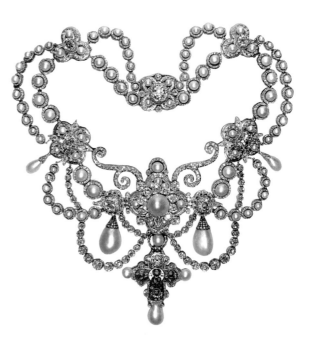

Among the gifts from the Prince of Wales was a suite of diamond and pearl jewellery, worn by the Princess on her wedding day. The Duke of Cambridge gave a gold bracelet with diamond-set enamelled buckle bearing the Prince of Wales's feathers.

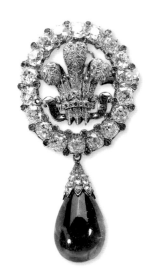

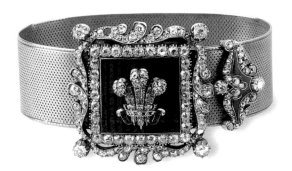

The gift from the Ladies of Bristol was a diamond-set brooch with an emerald pendant. The present from the Princess's train-bearers was an enamelled gold bracelet containing hand-coloured miniature portraits of each of the girls, beneath hinged flaps bearing their initials set in diamonds.

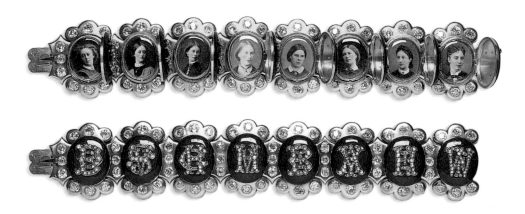

Princess Alexandra left Denmark for her married home in England soon after her eighteenth birthday. She travelled by sea to Hamburg and thence to Brussels before finally reaching Gravesend on 7 March 1863. She received a loving welcome from her future husband, and loud applause from the waiting crowds.

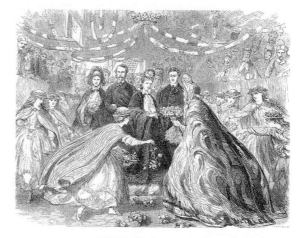

RECEPTION OF THE PRINCESS AT GRAVESEND.

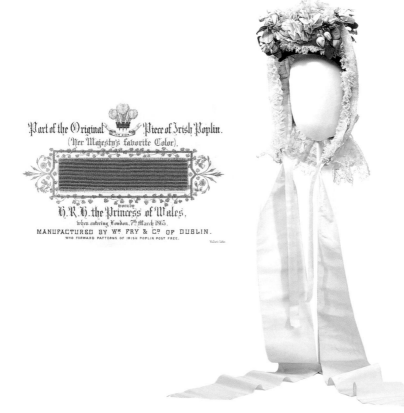

Part of the Original Piece of Irish Poplin.
(Her Majesty's favorite Color).

H.R.H. the Princess of Wales,
worn by
when entering London, 7th March 1863.
MANUFACTURED BY Wm FRY & Co OF DUBLIN.
WHO FORWARD PATTERNS OF IRISH POPLIN POST FREE.

Mindful of the fact that, fifteen months after the Prince Consort's death, Queen Victoria insisted on the continued observation of court mourning, Princess Alexandra wore a grey frock, white bonnet and lilac mantle made of Irish poplin. The rose-trimmed bonnet was made by the Princess herself.

The London populace gave Princess Alexandra an ecstatic welcome as she passed through the capital. Houses and offices were decorated with both the British and the Danish flags.

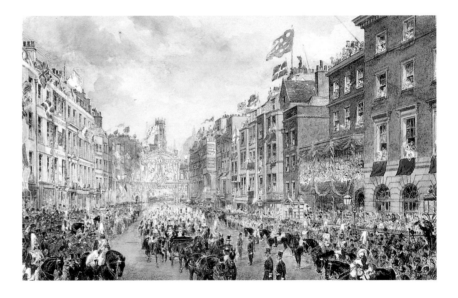

The Poet Laureate – Alfred, Lord Tennyson – wrote 'A Welcome to Alexandra', describing the bride as the 'Sea King's daughter from over the sea'. The page decoration was designed by Owen Jones.

The end of her journey was Windsor. Princess Alexandra and her immediate family were Queen Victoria's guests in the Castle for three nights before the wedding, which was celebrated at St George's Chapel on 10 March 1863. These rosettes or wedding favours – bearing Prince of Wales's feathers, portraits of the bride and groom, and the Danish flag – were worn by onlookers in both London and Windsor.

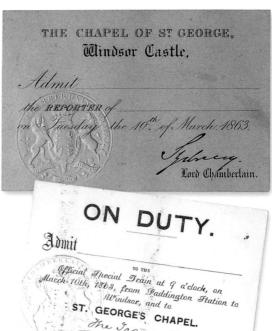

Admission tickets were issued to enable reporters to attend the service, and a special train was laid on to bring visitors from London to Windsor and back again.

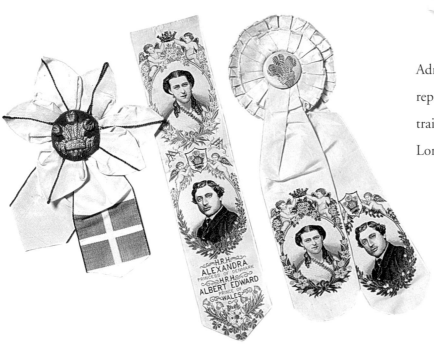

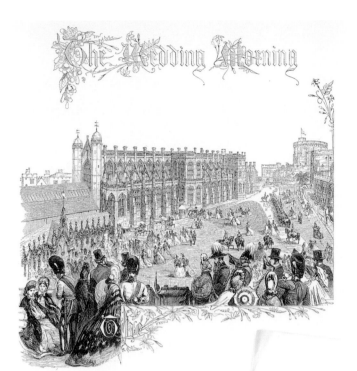

The guest list was the responsibility of Queen Victoria. Princess Mary of Cambridge was a first cousin of both Queen Victoria and the bride's mother. Her daughter, who married the son of the Prince and Princess of Wales in 1893, was the future Queen Mary.

The royal wedding was the subject of a lavish publication by *The Times* correspondent W. H. Russell. This included illustrations of the main events, and coloured records of many of the wedding presents.

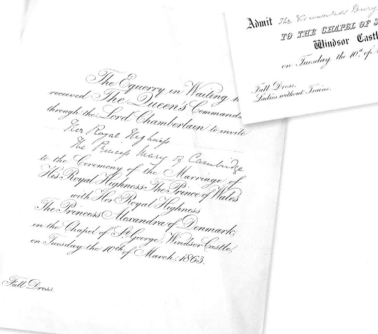

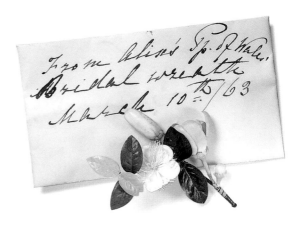

*[Handwritten letter, partially legible:]*

all above London Bridge were too frightening! one was thankful indeed ... then one was safe out of them! But we performed our expedition very successfully & were immensely interested by ye whole appearance. We were back at 2¼. At ½3. I walked v. Bartlett down to St J.'s, ye saw Pss Alexandra's wedding gown wh: really is very beautiful, silver tissue trimmed w. Honiton lace ye pattern of wh: is cornucopiae of roses, shamrocks, & thistles (most beautiful!) & bouquets of orange flower, ye skirt satin but covered v. ye same lace, & guirlandes of orange flower. it is très bon gout, light, young, & "royal"! made by Mrs James. Pss Mary's toilette too wasye very beautiful! mauve moiré ... silver, trimmed w. orange velvet & beautiful Honiton lace. ... Ella Taylor, & Arabella Bannerman ye ... such a wilderness confusion ...

Swags of artificial orange blossom and foliage were attached to the skirt, to match the broad circlet on the bride's head. A sprig from the headdress was kept by the Queen.

A detailed description of Princess Alexandra's wedding dress was provided by Lady Geraldine Somerset (above), who inspected it at St James's Palace before the ceremony and declared it 'très bon gout, light, young, & "royal"!' The lace was made at Honiton; the beautiful Brussels lace given by King Leopold could not be used as it was not British.

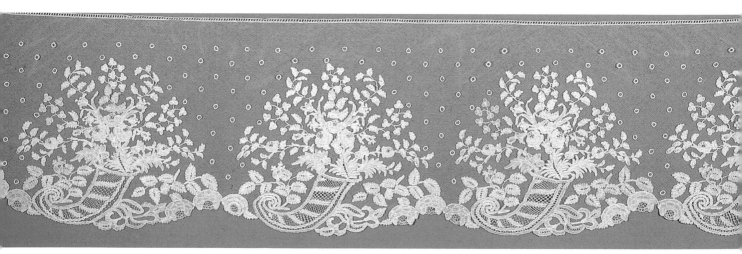

This was the first royal wedding since the introduction of photography as a reliable recording medium. Numerous photographs were taken of the bride and groom. The monochrome image was sometimes hand-coloured to give the appearance of a miniature painting.

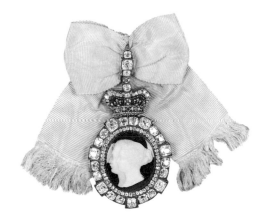

On her shoulder the bride wore the badge of the Order of Victoria and Albert that she had received from Queen Victoria on the day before her wedding.

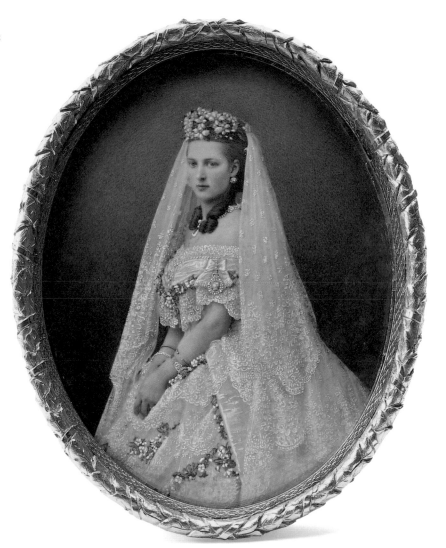

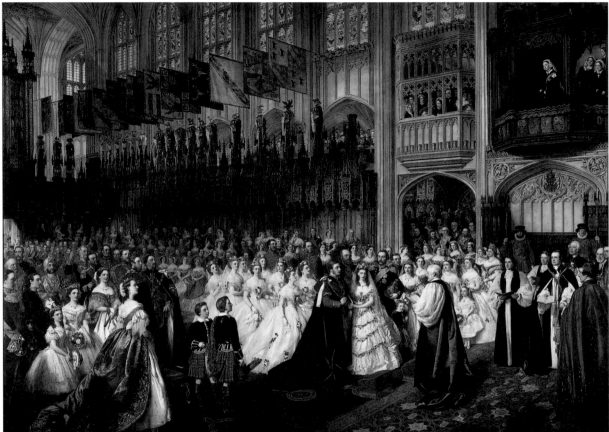

The wedding service included a chorale set to music by the Prince Consort. From her elevated position in the Edward IV Chantry overlooking the high altar, the widowed Queen Victoria was quite overcome.

The Prince of Wales's younger sisters and brothers also attended the ceremony. These photographs show Princesses Helena, Beatrice and Louise, and Princes Leopold and Arthur.

After the wedding the bridal couple and guests proceeded to the royal apartments in the Castle, where the Marriage Register was signed. This is one of the cakes displayed at the Wedding Breakfast.

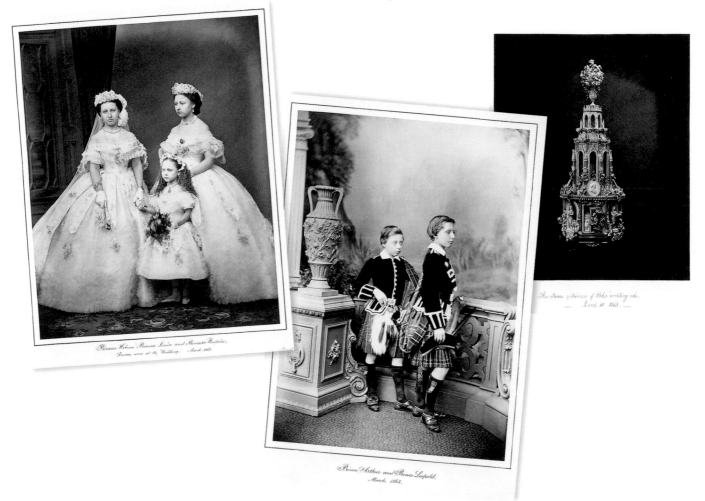

*Princess Helena, Princess Louise and Princess Beatrice. Dresses worn at the Wedding. March 1863.*

*Prince Arthur and Prince Leopold. March 1863.*

*The Prince & Princess of Wales' wedding cake. March 10 1863.*

The Queen insisted that her children, including the newly married couple, should be photographed with her, by a bust of Prince Albert, on the day of the wedding.

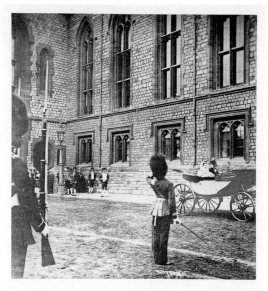

*Departure of the Prince & Princess of Wales from Windsor Castle for Osborne — March 10 1863 .*

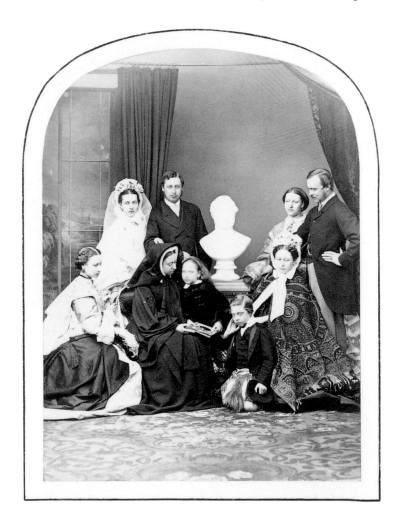

The bride and groom were also photographed in their open carriage as it departed from the Quadrangle of Windsor Castle.

The honeymoon was to be spent at the royal holiday home – Osborne House on the Isle of Wight (opposite).

By the time that the bride and groom reached Portsmouth, it was dark. Celebratory illuminations had been organised both there and in the Isle of Wight. In this watercolour the Royal Yacht is shown passing in front of six ornamented ships at Spithead.

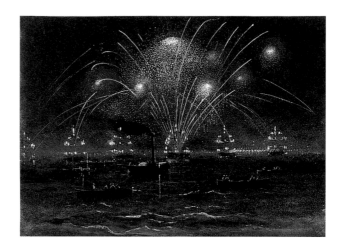

Among the letters sent by the Prince and Princess of Wales from Osborne were these to the bride's mother. The Prince signed his letter 'your most devoted and grateful son-in-law Bertie'.

The Prince and Princess of Wales had five children and celebrated their Silver Wedding anniversary in 1888. In 1901 the Prince succeeded his mother on the throne, as King Edward VII. Queen Alexandra outlived him by fifteen years and died in 1925, during the reign of King George V, their only surviving son.

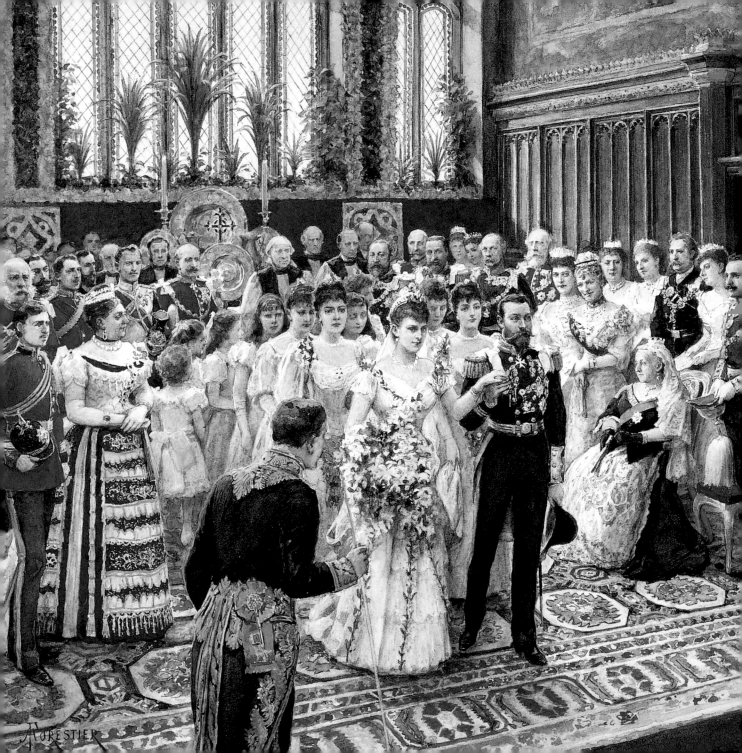

# VICTORIA MARY
## AND
# GEORGE

6 JULY 1893

The future Queen Mary was born Princess Victoria Mary of Teck on 26 May 1867 at Kensington Palace. She was the eldest child and only daughter of Francis, Duke of Teck, and Princess Mary Adelaide of Cambridge. Her mother was a granddaughter of George III and first cousin of Queen Victoria. Her father was the only son of Alexander, Duke of Württemberg, by his morganatic (non-royal) marriage.

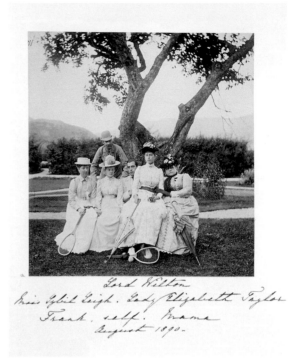

Princess May (as she was known in her family) spent most of her childhood in England. In March 1872 she and her brothers Adolphus, Francis and Alexander were sketched playing with the Prince of Wales's children at Chiswick. The three older children are the Princess, who is holding a doll, and Eddie and George – the two sons of the Prince of Wales.

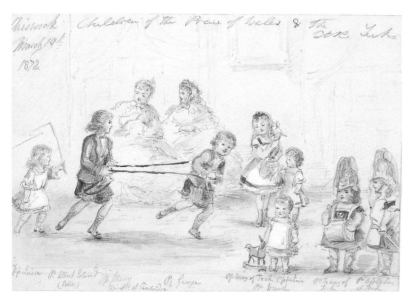

The Princess's family home from 1870 was White Lodge, Richmond, now the home of the Royal Ballet School. A tennis party in 1890 was recorded in the photograph shown to the left.

Queen Victoria was impressed by Princess May's intelligence, and by her steady character. She therefore encouraged a match with the Prince of Wales's elder son, Eddie (Prince Albert Victor, Duke of Clarence). After a brief courtship, the couple became engaged in December 1891. But within six weeks the Prince had died of influenza.

This family photograph, signed by each of the sitters, was taken on the occasion of the Silver Wedding Anniversary of the Duke and Duchess of Teck in June 1891. Princess May – by then aged 24 – stands between her three brothers.

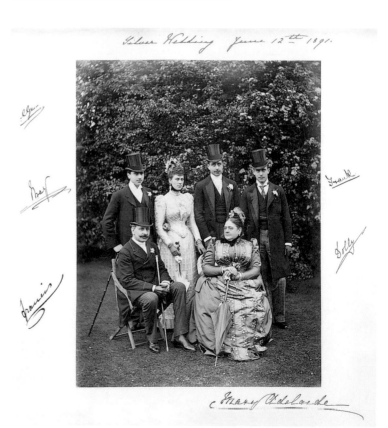

The future King George V was born Prince George of Wales on 3 June 1865 at Marlborough House, the London home of his parents, the Prince and Princess of Wales. The photograph below shows the tiny boy with his mother and elder brother, Eddie, at Balmoral in September 1866. Prince George sits in the far pannier basket. The hand-coloured photograph shows him two years later, while the photograph in Highland dress (far right) is from 1869.

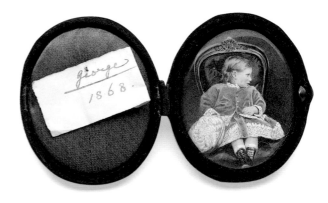

In November 1875 Prince George wrote from Sandringham to thank Mrs Dalton, his tutor's wife, for the shells she had sent.

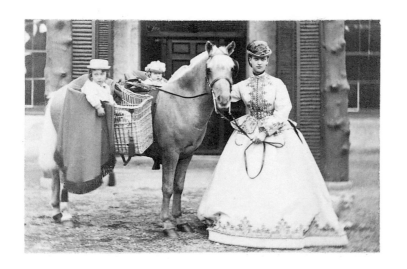

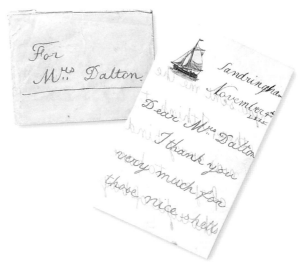

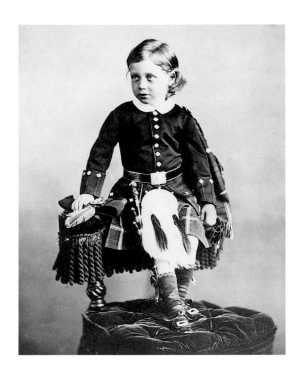

Ten years later, in January 1892, Prince George's naval career was brought to an abrupt end. Following Prince Albert Victor's sudden death he was now second in the line of succession to the throne. In May 1892 Prince George was created Duke of York.

As the second son, Prince George was destined for a career in the Royal Navy. He was portrayed with his elder brother in 1882 at the end of their cruise in the *Bacchante*. The Princes were close friends. Here they both wear midshipmen's uniform.

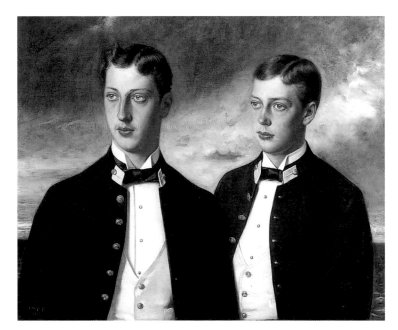

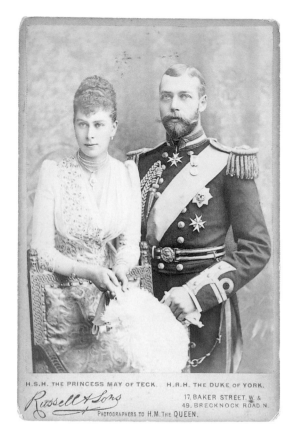

H.S.H. THE PRINCESS MAY OF TECK.    H.R.H. THE DUKE OF YORK.

*Russell & Sons*    17, BAKER STREET. W. &
49, BRECKNOCK ROAD. N.
PHOTOGRAPHERS TO H.M. THE QUEEN.

the garden, her first walk. May came
to tea with us at 5.0. Afterwards
we two walked in the garden here,
& I proposed to her & the darling
girl consented to be my wife, I
am so happy. Went with her to White
Lodge & got aunt Mary & Teck's consent,
telegraphed to Grandmama, who
answered me at 8.0. when I got
back – Dined quietly with Louise &

Telegrams requesting – and then receiving –
the Queen's consent were rapidly exchanged,
and engagement photographs were
soon available.

POST OFFICE TELEGRAPHS.

Government Dispatch Nº.                    May 3ʳᵈ 1893

TO   The Queen
     Windsor

Melampus
I am engaged to George
May & ask your
consent –

Answer
G. Cadby green

Princess May and Prince George had known
each other since childhood. In late 1892, after
the unexpected death of Prince Albert Victor,
Queen Victoria encouraged the idea that
Princess May should instead marry Prince
George (now Duke of York). The courtship
proceeded steadily and on 3 May 1893 the
Duke recorded in his diary (above right) that
'the darling girl consented to be my wife'.

The engagement was to be brief – a mere two months – so preparations for the wedding had to be made rapidly. Before the end of May the Princess and her mother were busy selecting the trousseau, which was to be of entirely British manufacture. Just over two weeks before the wedding, Princess May wrote to her future husband describing how she had been 'trying on all day'.

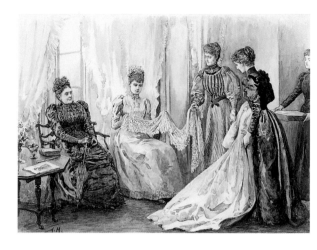

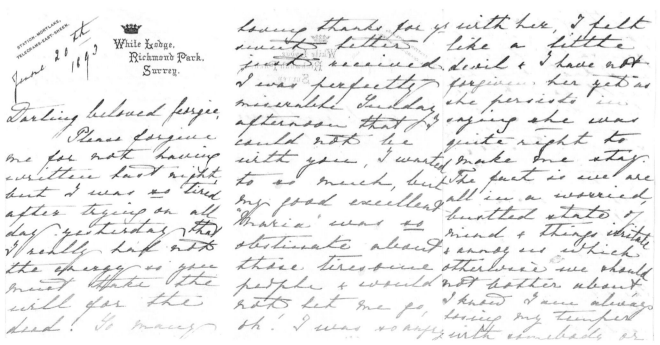

Useful and decorative items were soon being delivered to White Lodge for the Princess's future use. These included a feather-trimmed satin sachet embroidered with trefoils and the bride's initials.

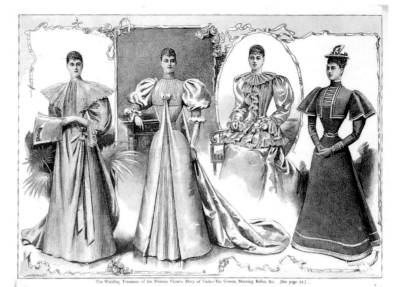

The Wedding Trousseau of the Princess Victoria Mary of Teck—Tea Gowns, Morning Robes, &c. (See page 24.)

One illustrated magazine, *The Gentlewoman*, included a series of plates showing the new clothes ordered for Princess May's wardrobe (shown above). Another – *The Lady's Pictorial* – described forty outdoor suits, fifteen ball-dresses, five tea-gowns and a vast number of bonnets, shoes and gloves.

In the days immediately before the wedding, the bride's parents gave a celebratory garden party at White Lodge. A large cake was the crowning decoration of the refreshment table.

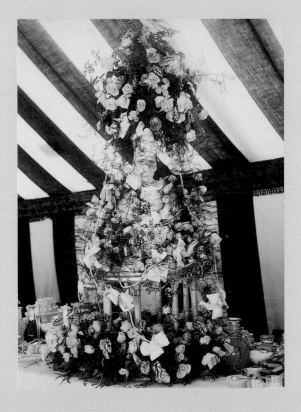

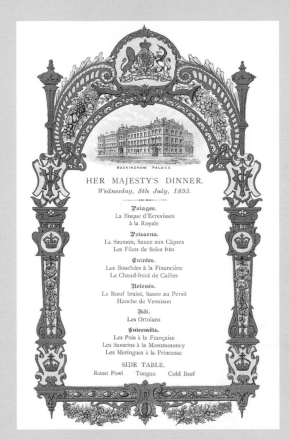

BUCKINGHAM PALACE

HER MAJESTY'S DINNER,
Wednesday, 5th July, 1893.

Potages.
La Bisque d'Ecrevisses
à la Royale

Poissons.
Le Saumon, Sauce aux Câpres
Les Filets de Soles frits

Entrées.
Les Bouchées à la Financière
Le Chaud-froid de Cailles

Relevés.
Le Bœuf braisé, Sauce au Persil
Hanche de Venaison

Rôt.
Les Ortolans

Entremêts.
Les Pois à la Française
Les Savarins à la Montmorency
Les Meringues à la Princesse

SIDE TABLE.
Roast Fowl    Tongue    Cold Beef

On the evening before the wedding Queen Victoria gave a dinner at Buckingham Palace, culminating in 'Les Meringues à la Princesse'.

Over 1,400 presents had been delivered to the homes of the bride and groom. The bride's presents were stacked on any free surfaces at White Lodge. It was estimated that the jewellery and plate were together worth £300,000.

On 3 July – three days before the wedding – the Duke of York wrote from Marlborough House to 'My own darling sweet May' to enclose a list of the presents that had arrived for her. He noted that 'All my presents have now gone to the Imperial Institute, & yours are there too'.

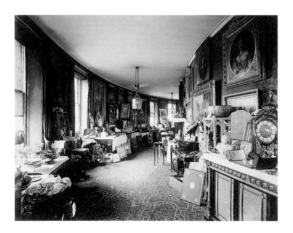

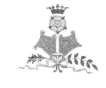

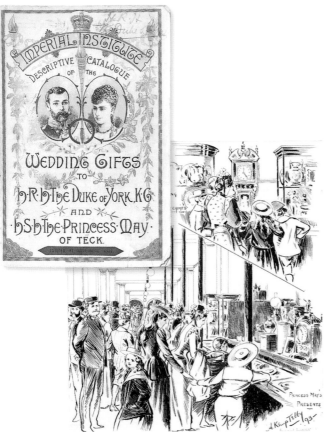

Among the decorative – and occasionally practical – gifts was this pair of Tiffany opera glasses, presented by the actor and director Sir Augustus Harris. He was responsible for the special 'state performance' of *Romeo et Juliette* at the Royal Opera House, Covent Garden, on the eve of the Royal Wedding. The part of Juliet was played by Nellie Melba.

The display of wedding gifts at the Imperial Institute, South Kensington, attracted a thousand visitors an hour. The admission income went to a charity, the Victoria Fund.

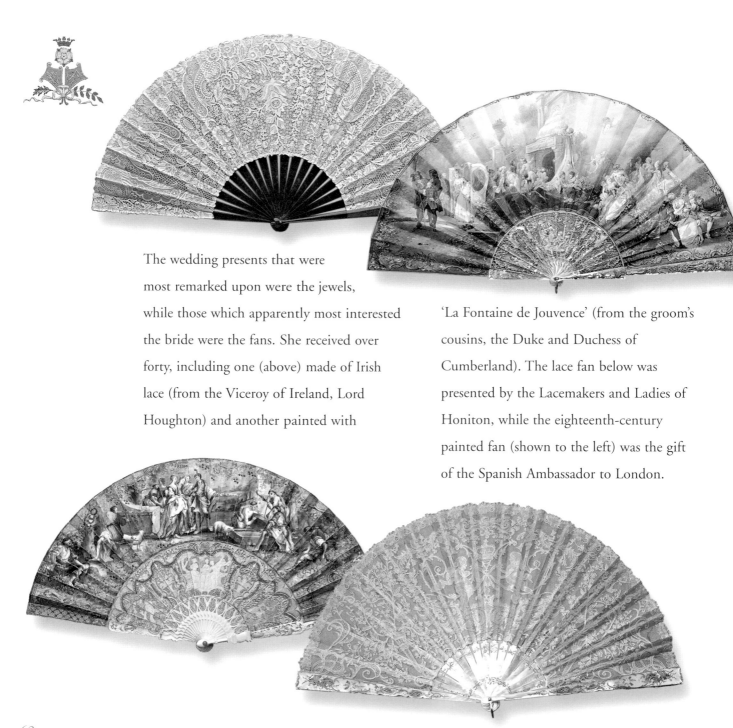

The wedding presents that were most remarked upon were the jewels, while those which apparently most interested the bride were the fans. She received over forty, including one (above) made of Irish lace (from the Viceroy of Ireland, Lord Houghton) and another painted with 'La Fontaine de Jouvence' (from the groom's cousins, the Duke and Duchess of Cumberland). The lace fan below was presented by the Lacemakers and Ladies of Honiton, while the eighteenth-century painted fan (shown to the left) was the gift of the Spanish Ambassador to London.

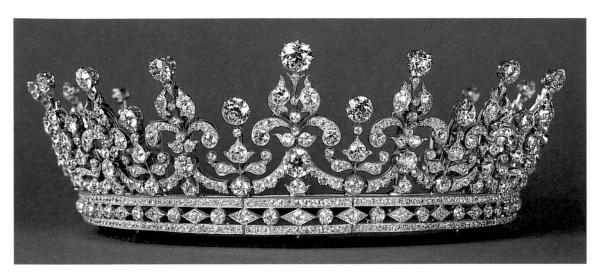

The gifts included quantities of diamond-set jewellery. This diamond tiara was presented by the Girls of Great Britain and Ireland.

The County of Cornwall gave the bride a ruby and diamond bracelet incorporating a detachable centrepiece in the shape of a rose.

These diamond-set bow brooches were presented by the Inhabitants of Kensington, and by the County of Dorset. The former includes a large pendant pearl.

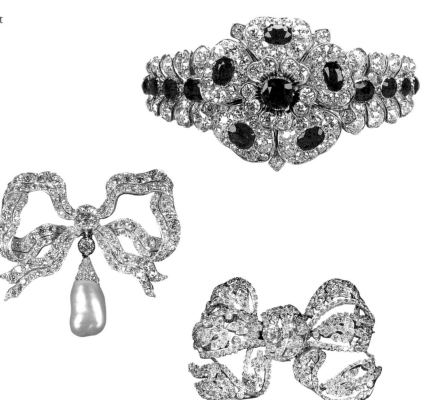

The marriage ceremony took place at the Chapel Royal, St James's Palace, on 6 July 1893. This velvet-covered copy of the ceremonial was used by the bride.

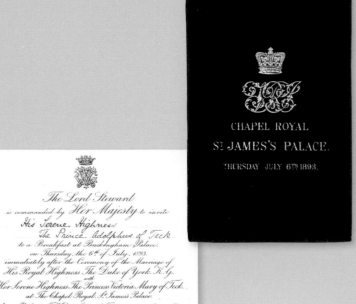

CHAPEL ROYAL
ST JAMES'S PALACE.
THURSDAY JULY 6TH 1893.

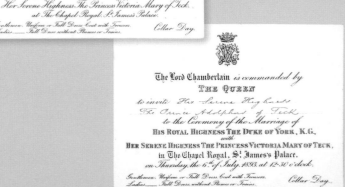

The Lord Steward
is commanded by Her Majesty to invite
His Serene Highness
The Prince Adolphus of Teck
to a Breakfast at Buckingham Palace,
on Thursday, the 6th of July, 1893,
immediately after the Ceremony of the Marriage of
His Royal Highness The Duke of York, K.G.
with
Her Serene Highness The Princess Victoria Mary of Teck,
at The Chapel Royal, St James's Palace.
Gentlemen. Uniform or Full Dress Coat with Trousers.
Ladies.— Full Dress without Plumes or Trains.
Collar Day.

The Lord Chamberlain is commanded by
THE QUEEN
to invite His Serene Highness
The Prince Adolphus of Teck
to the Ceremony of the Marriage of
HIS ROYAL HIGHNESS THE DUKE OF YORK, K.G.,
with
HER SERENE HIGHNESS THE PRINCESS VICTORIA MARY OF TECK,
in The Chapel Royal, St James's Palace,
on Thursday the 6th of July, 1893, at 12.30 o'clock.
Gentlemen. Uniform or Full Dress Coat with Trousers.
Ladies.— Full Dress without Plumes or Trains.
Collar Day.

The bridegroom recorded the events of the bright summer day in his diary. From his family home at Marlborough House he proceeded to Buckingham Palace, and thence via Piccadilly back to St James's.

Many of those who witnessed the procession wore 'favours'. Baroness Burdett-Coutts gave one of her specially manufactured decorations (right) to each of the children who watched the procession from her house at Stratton Street, overlooking Piccadilly.

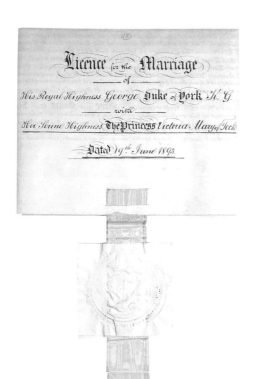

The Danish painter Laurits Tuxen recorded the ceremony for Queen Victoria, who had been married in the Chapel Royal over fifty years previously. The Queen wrote: 'Dear May looked so pretty & quiet & dignified. She was vy. simply & prettily dressed – and wore her Mother's Veil lace.' The bride's father and brothers stand to the left of the altar, while the groom's parents stand to the right. The bride's mother is seated in the foreground on the right.

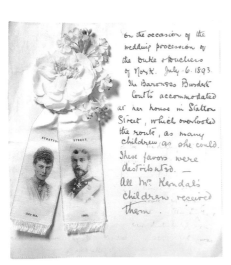

On the occasion of the wedding procession of the Duke & Duchess of York. July. 6. 1893. The Baroness Burdett Coutts accommodated at her house in Stratton Street, which overlooked the route, as many children as she could. These favors were distributed. – All Mrs Kendal's children received them.

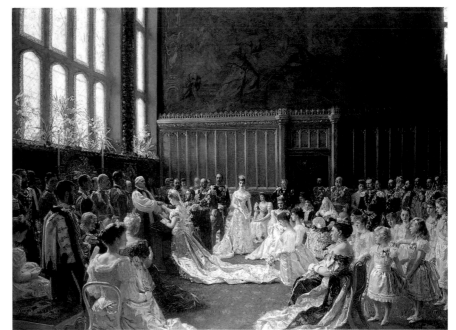

The bride's wedding dress and train were
made of ivory silk satin woven in the East
London (Spitalfields) silk mills. The bodice
was brocaded in ivory and silver thread. Both
bodice and skirt were trimmed with Honiton
lace and orange blossom. The lace veil and
some of the other lace had been worn by the
bride's mother at her own wedding in 1866.
The train had a design of roses, shamrocks
and thistles in silver on a white ground.

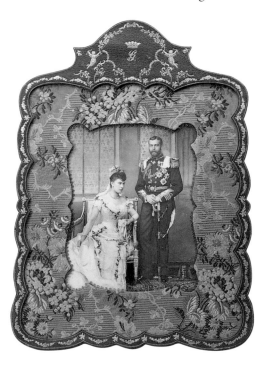

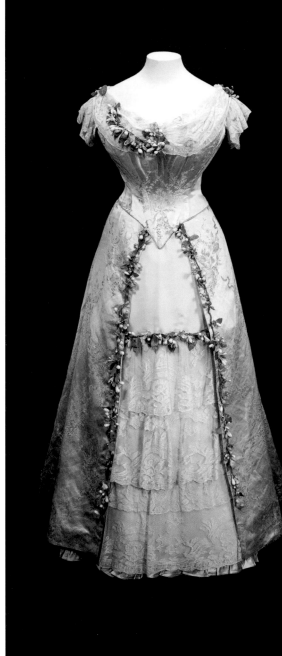

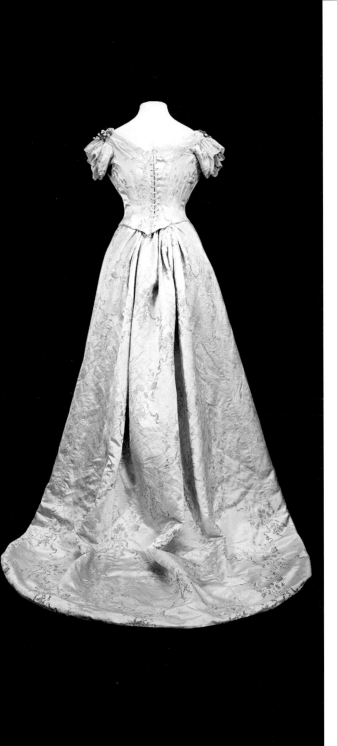

Queen Mary identified this Honiton lace handkerchief, and these fine silk stockings, as those that she had used or worn on her wedding day.

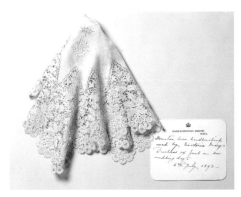

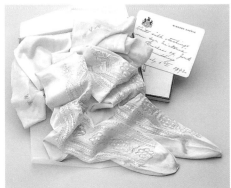

After the service, the bride and groom were photographed with their bridesmaids – nine granddaughters and one great-granddaughter of Queen Victoria. The Queen recorded that they 'looked vy. sweet in white satin, with a little pink & red rose on the shoulder & some small bows of the same on the shoes'.

Each bridesmaid received a bracelet with a diamond and enamel Rose of York centrepiece.

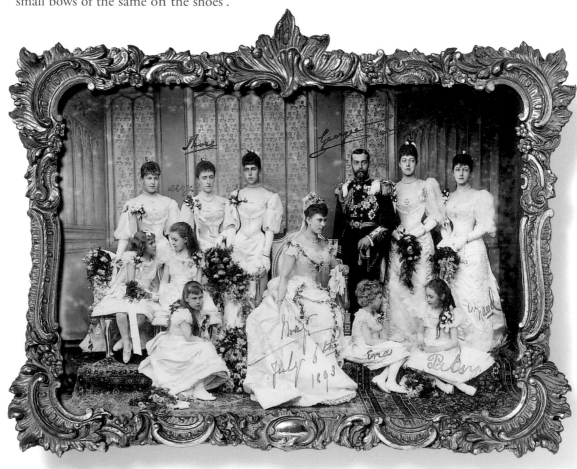

The royal party proceeded to the State Dining Room at Buckingham Palace, where the tables were laid for the Wedding Breakfast. The principal wedding cake (shown lower right) was made by the Queen's confectioner at Windsor Castle. A number of other cakes were on display in the Ball Room, where the guests were entertained to a buffet.

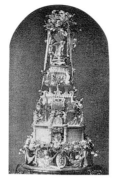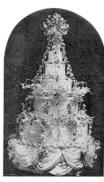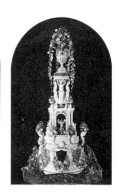

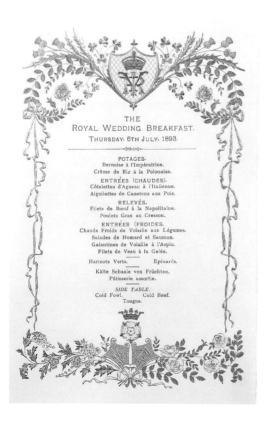

THE
ROYAL WEDDING BREAKFAST.
THURSDAY, 6TH JULY, 1893.

POTAGES.
Bernoise à l'Impératrice.
Crème de Riz à la Polonaise.

ENTRÉES (CHAUDES).
Côtelettes d'Agneau à l'Italienne.
Aiguillettes de Canetons aux Pois.

RELEVÉS.
Filets de Bœuf à la Napolitaine.
Poulets Gras au Cresson.

ENTRÉES (FROIDES).
Chauds Froids de Volaille aux Légumes.
Salades de Homard et Saumon.
Galantines de Volaille à l'Aspic.
Filets de Veau à la Gelée.

Haricots Verts.        Épinards.

Kälte Schaale von Früchten.
Pâtisserie assortie.

SIDE TABLE.
Cold Fowl.        Cold Beef.
Tongue.

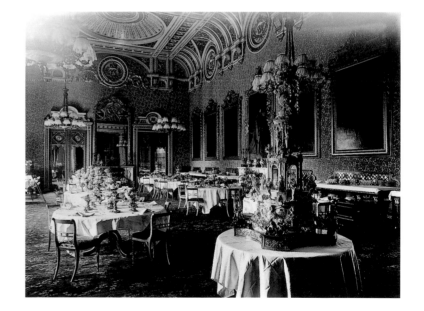

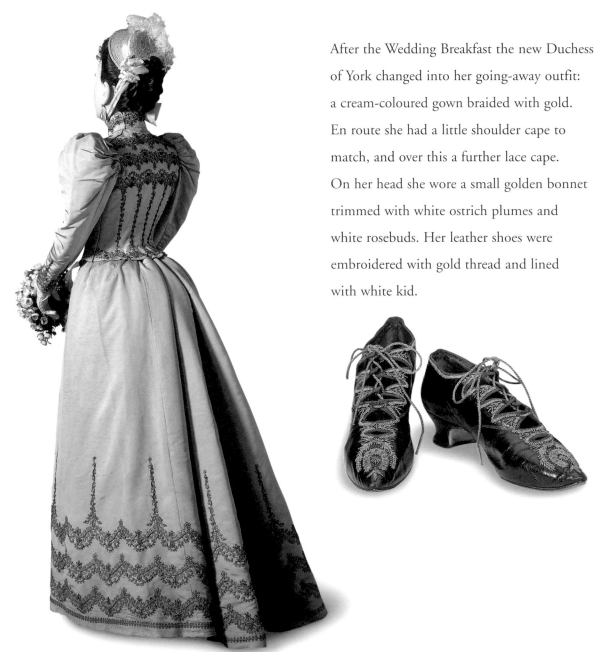

After the Wedding Breakfast the new Duchess of York changed into her going-away outfit: a cream-coloured gown braided with gold. En route she had a little shoulder cape to match, and over this a further lace cape. On her head she wore a small golden bonnet trimmed with white ostrich plumes and white rosebuds. Her leather shoes were embroidered with gold thread and lined with white kid.

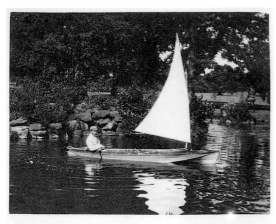

In the continuing heat of July 1893 they often took their meals in the summer-house, or relaxed on the lake. On 15 July they gave their first dinner party at York Cottage.

The royal couple spent their honeymoon at York Cottage on the Sandringham estate. The house had been given to the Duke by his father as a wedding present, and it remained the Yorks' country home for the next thirty-three years.

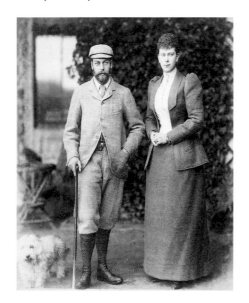

Following the death of Queen Victoria in 1901 the Duke and Duchess of York became Prince and Princess of Wales, and on King Edward VII's death in 1910 they succeeded as King George V and Queen Mary. Their long period of married life ended with the King's death in January 1936. There were six children of the marriage. Queen Mary survived until March 1953, to see her granddaughter, Princess Elizabeth, accede to the throne.

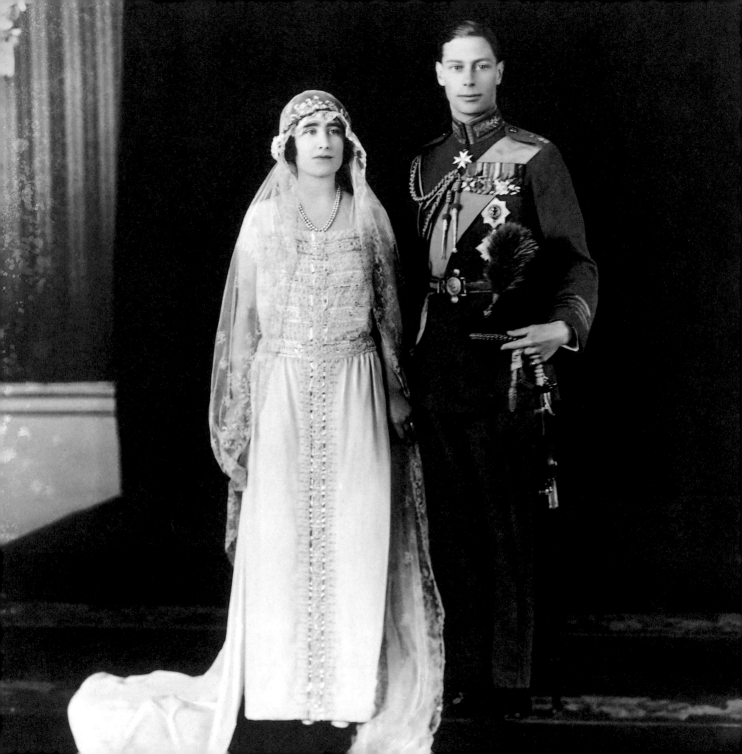

# ELIZABETH
### AND
## ALBERT

## 26 APRIL 1923

The future Queen Elizabeth The Queen Mother was born Elizabeth Bowes Lyon on 4 August 1900. She was the ninth child and fourth daughter of Lord Glamis, who succeeded his father as the 14th Earl of Strathmore and Kinghorne in 1904. Lady Elizabeth's childhood was divided between her family homes: Glamis Castle (right) in Angus, St Paul's Walden Bury in Hertfordshire (opposite), and in London.

Much of her early life was spent with her younger brother David, born in 1902. In one photograph they stand at either side of their father, while in another (of 1909) they are shown in fancy dress costumes made by their mother.

The Countess of Strathmore was born Nina Cecilia Cavendish-Bentinck. If she had been a boy she would have succeeded as Duke of Portland on the death of her unmarried cousin, the 5th Duke; instead the title passed to the son of her father's younger brother. Lady Strathmore oversaw the education of the future Queen, who received lessons at home. This portrait of Lady Strathmore was a wedding present to her daughter in 1923.

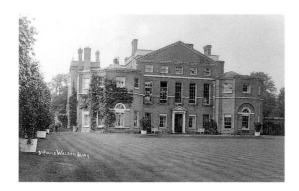

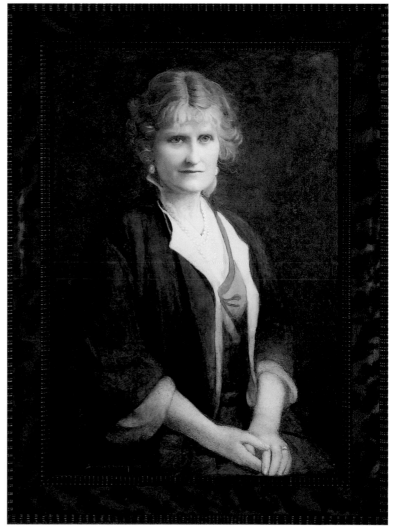

The future King George VI was born at
York Cottage on the Sandringham estate
on 14 December 1895. The second son
of the Duke and Duchess of York (later
King George V and Queen Mary), he was
christened Albert Frederick Arthur George
but was known by his family as Bertie.
He is seen in the centre of the photograph
below with his elder brother David, his
younger brother Henry, and his sister Mary.
The letter below was sent to his
father in 1901.

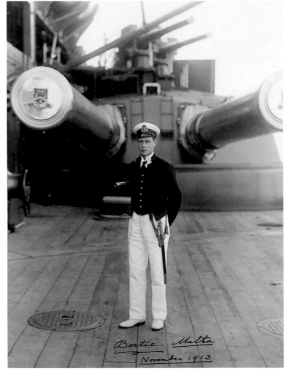

Bertie – Malta
November 1913.

In 1909 the Prince entered the Royal Naval College, Osborne, where the Captain (Arthur Christian) recognised in him 'the grit and "never say I'm beaten" spirit'. From Osborne he transferred to Dartmouth and thence to active service. In November 1913 he was a midshipman on board the battleship HMS *Collingwood* at Malta. He describes his time there in a letter home (opposite).

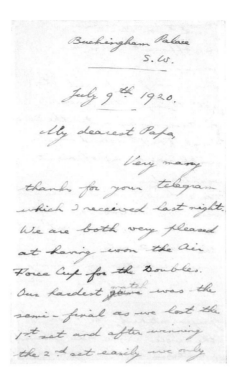

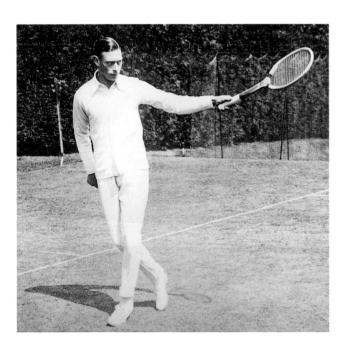

The Prince was a keen sportsman and particularly excelled at tennis. In 1920, two years after joining the Royal Naval Air Service (later amalgamated into the Royal Air Force), he informed his father that he had won the Air Force Cup tennis doubles with his friend Wing Commander Louis Greig.

The Prince and Lady Elizabeth had first met as children, in 1905. In the summer of 1920 (soon after the Prince had been created Duke of York) they attended the same dance in London. This marked the start of a prolonged courtship.

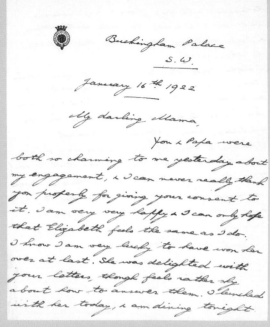

Buckingham Palace
S.W.
January 16th 1922

My darling Mama,

You & Papa were both so charming to me yesterday about my engagement, & I can never really thank you properly for giving your consent to it. I am very very happy & I can only hope that Elizabeth feels the same as I do. I know I am very lucky to have won her over at last. She was delighted with your letters, though feels rather shy about how to answer them. I lunched with her today, & am dining tonight

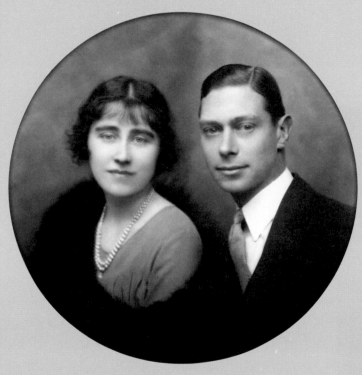

Lady Elizabeth treasured her carefree life within a large and loving family, and among her many close friends. But at St Paul's Walden Bury in mid-January 1923 she finally accepted the Duke's offer of marriage. On 15 January the engagement was made public and on the following day the Duke wrote to his mother expressing his great happiness.

Individual portrait drawings of the engaged
couple were commissioned as wedding
presents from the American artist John Singer
Sargent, who remarked that Lady Elizabeth
was 'the only completely unselfconscious sitter
I have ever had'.

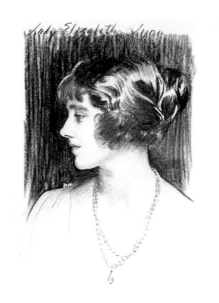

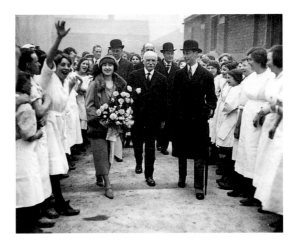

During their three-month engagement
the Duke and Lady Elizabeth travelled
frequently between Scotland and England.
In mid-March they visited the McVitie &
Price factory in Edinburgh, which was to
produce the principal wedding cake.

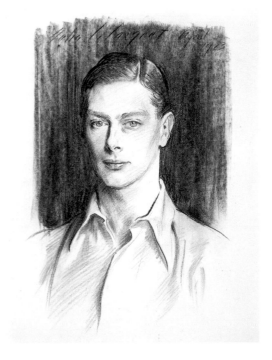

The wedding presents soon began to arrive. From her father Lady Elizabeth received a diamond tiara in the form of a garland of wild roses. Another tiara was included in the suite of diamond and turquoise jewellery given by the King, while Queen Mary gave the bride a diamond and sapphire necklace.

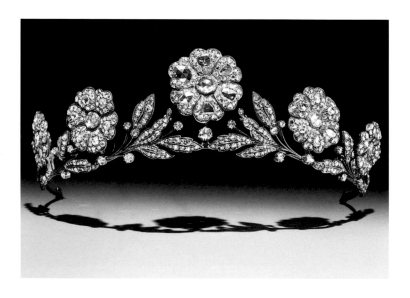

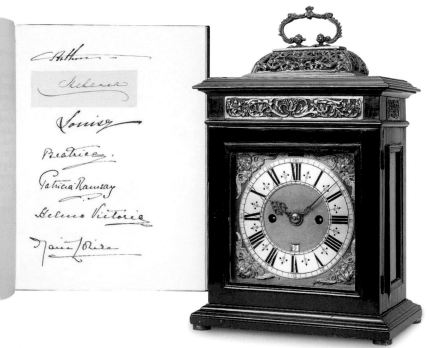

Gifts to the bridegroom included this late seventeenth-century English clock by John Ebsworth, accompanied by a volume containing the signatures of all the members of the Royal Family who had contributed to the present.

Lady Elizabeth's unmarried aunt, Violet Cavendish-Bentinck, gave a symbolic representation of the wedding painted by the Italian artist Ricciardo Meacci. The British royal arms and the arms of the Strathmore family are shown in the centre, above idealised figures of the bride and groom.

The bride's mother gave the Duke of York a miniature portrait of her daughter in a jewelled frame.

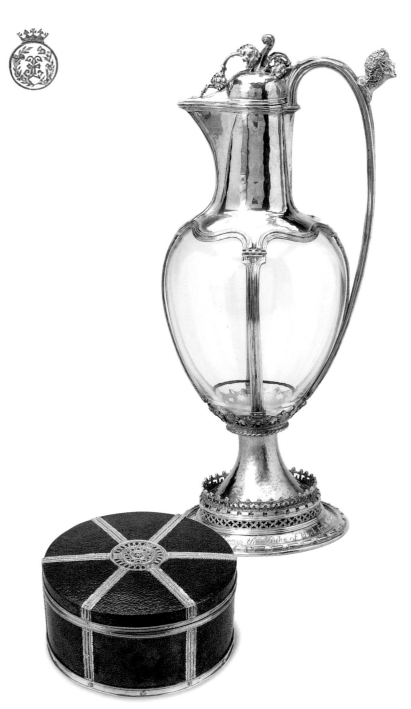

Other gifts included a set of enamelled spoons with strainer, made by the Norwegian silver-smith David Andersen, from the King and Queen of Norway; a shagreen box with silver mounts by Paul Cooper, from Mr and Mrs McEwan; and a silver-mounted crystal claret jug made by Omar Ramsden, from the Royal Academy of Arts. The Worshipful Company of Needlemakers presented the bride with one thousand gold-eyed needles.

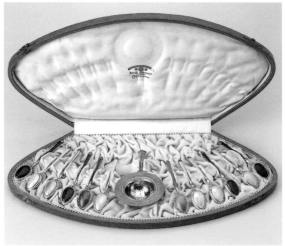

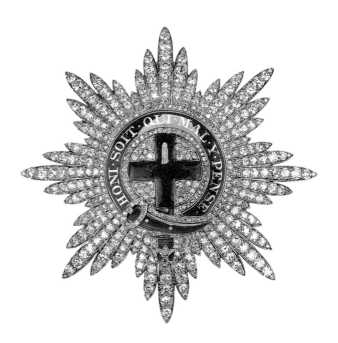

THE MARRIAGE OF HIS ROYAL
HIGHNESS THE DUKE OF YORK
WITH THE
LADY ELIZABETH BOWES-LYON.

*26th April, 1923.*

<u>DRESS TO BE WORN.</u>

<u>LADIES—</u>
Morning Dress with hats; also Orders and Decorations.

<u>GENTLEMEN—</u>
Navy, Army and Air Force.—Full Dress Uniform for Officers in possession of it. Officers of the Army and Air Force not in possession of Full Dress Uniform of their rank—Service Dress.

Royal Households and Civil Service.—Full Dress Coat with Trousers. Those not in possession of Full Dress Coat—Levée Dress.

Civilians.—Court Dress.

The Garter Star set with diamonds was a gift to the Duke from the Royal Navy. In 1947 it was given to Princess Elizabeth on her appointment as Lady of the Garter, shortly before her own wedding.

In spite of the increasing use of the motor car, carriages – for which passes were issued – were used, as at previous weddings. The dress code was clearly stated in the instructions that accompanied the invitations.

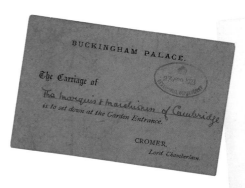

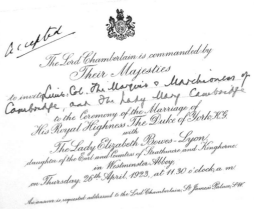

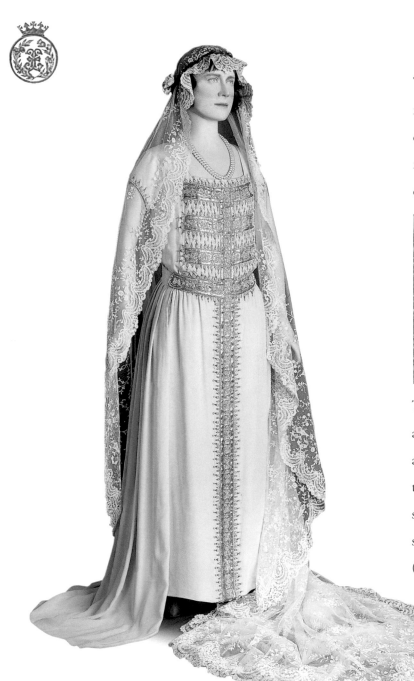

The bride's dress of ivory chiffon moiré was made by Mrs Handley Seymour. It was described in *The Times* as 'the simplest ever made for a royal wedding' and was quite distinct from previous tailored royal gowns.

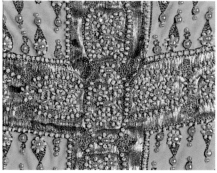

The front of the bodice and skirt was appliquéd with silver lamé, gold embroidery, and pearl and paste beads. There were two trains: one was fastened at the hips, while the second – made of tulle – was attached at the shoulders. The point de Flandres lace veil (lent by Queen Mary) was held in place by a circlet of myrtle, fixed low on the head. At either side were knots formed of white roses and heather.

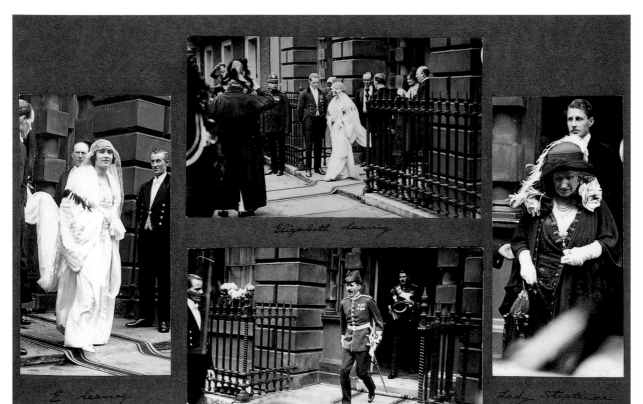

*Elizabeth leaving*

*E. leaving.*

*Jock & Mike leaving*

*Lady Strathmore leaving*

The Duke of York and Lady Elizabeth Bowes Lyon were married at Westminster Abbey on 26 April 1923. The groom was 27, the bride 22. Photographs of the bride and her family leaving their London home – No. 17 Bruton Street, Mayfair – were later pasted into the Duke's album.

The Earl of Strathmore and Lady Elizabeth drove to Westminster Abbey in a State Landau. The Abbey had recently been the venue for the weddings of Princess Patricia of Connaught and of the groom's sister, Princess Mary. Lady Elizabeth had been one of the bridesmaids for her future sister-in-law.

The bridegroom wore the dress uniform of the Royal Air Force, with the Riband and Star of the Order of the Garter and the Star of the Order of the Thistle. He had received the Thistle on his wedding day, as a tribute to his Scottish bride. His supporters were his younger brothers, Henry and George.

As the bride processed from the west door towards the altar, she placed her bouquet on the tomb of the Unknown Warrior. After the couple had exchanged marriage vows, they signed the Marriage Register in the chapel of Edward the Confessor.

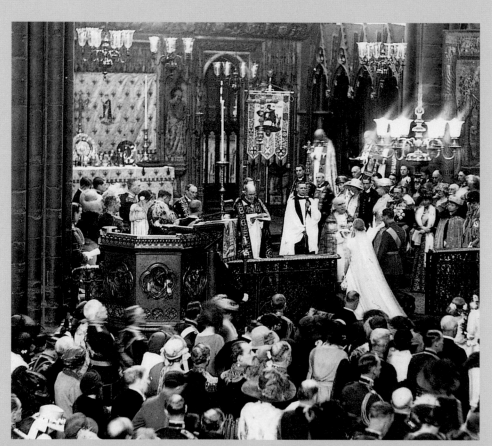

This Marriage was solemnized between us this Twenty sixth day of April One thousand nine hundred and twenty three.

*Albert*

*Elizabeth Anne Lyon*

SOLEMNIZATION OF MATRIMONY.

Into which holy estate these two persons present come now to be joined. Therefore if any man can shew any just cause, why they may not lawfully be joined together let him now speak, or else hereafter for ever hold his peace.

¶ *Then speaking unto the persons that shall be married, the Minister shall say,*

I REQUIRE and charge you both, as ye will answer at the dreadful day of judgment when the secrets of all hearts shall be disclosed, that if either of you know any impediment, why ye may not be lawfully joined together in Matrimony, ye do now confess it. For be ye well assured, that so many as are coupled together otherwise than God's word doth allow are not joined together by God; neither is their Matrimony lawful.

¶ *If no impediment be alledged, then shall the Minister say unto the Man,*

ALBERT FREDERICK ARTHUR GEORGE, wilt thou have this Woman to thy wedded wife, to live together after God's ordinance in the holy estate of Matrimony? Wilt thou love her, comfort her, honour, and keep her in sickness and in health; and, forsaking all other, keep thee only unto her, so long as ye both shall live?

¶ *The Man shall answer,*

I will.

¶ *Then shall the Minister say unto the Woman,*

ELIZABETH ANGELA MARGUERITE, wilt thou have this Man to thy wedded husband, to live together after God's ordinance in the holy estate of Matrimony? Wilt thou obey him, and serve him, love, honour, and keep him in sickness and in health; and, forsaking all other, keep thee only unto him, so long as ye both shall live?

¶ *The Woman shall answer,*

I will.

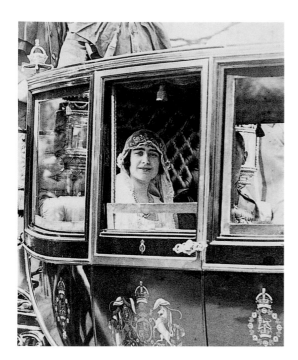

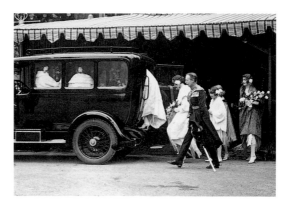

After the service the bride and groom made their way back to Buckingham Palace in the Glass Coach, while the eight bridesmaids (mostly chosen as personal friends rather than royal relations) travelled in a large motor vehicle. They had each received from the bridal couple the gift of a carved crystal rose-shaped brooch with the diamond initials *E* and *A* in the centre.

On the balcony at Buckingham Palace the Duke and Duchess of York, standing between Queen Alexandra and Queen Mary (on the left) and King George V, greeted the crowds below. This was the first royal wedding to be recorded on film. The newsreels (including the balcony episode) were available for viewing on the evening of the wedding day.

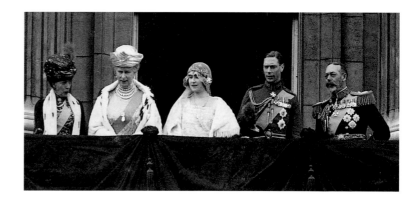

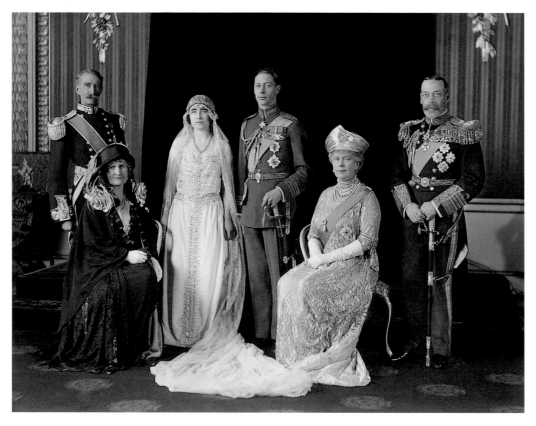

Formal wedding photographs were taken inside the Palace.

The Wedding Breakfast took place in the State Dining Room. The menu included Consommé à la Windsor, Suprèmes de Saumon Reine Mary, Côtelettes d'Agneau Prince Albert, Chapons à la Strathmore, and Fraises Duchesse Elizabeth.

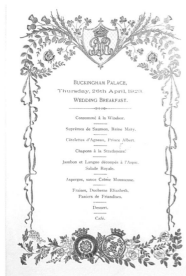

A number of ornately decorated wedding cakes were provided. The porcelain ornaments from one of these have survived.

The cake supplied by McVitie & Price was 9 feet high (about 3m) and weighed 800 pounds (about 365kg).

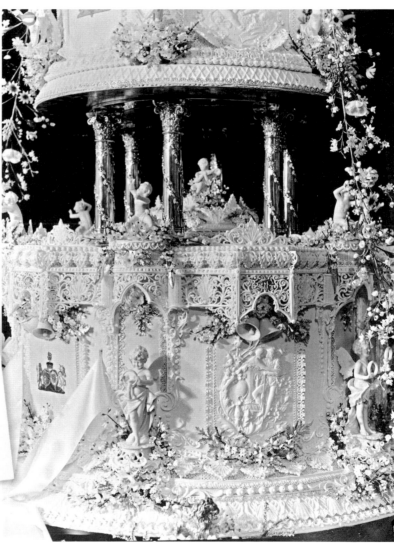

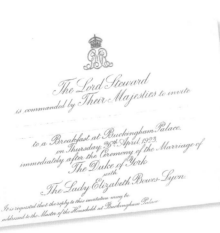

The Lord Steward is commanded by Their Majesties to invite

to a Breakfast at Buckingham Palace, on Thursday 26th April 1923, immediately after the Ceremony of the Marriage of The Duke of York with The Lady Elizabeth Bowes-Lyon.

It is requested that the reply to this invitation may be addressed to the Master of the Household at Buckingham Palace

The Duke and Duchess of York left Buckingham Palace for their honeymoon in an open-topped landau, amidst tumultuous applause from the crowds. At Waterloo they boarded a train for Bookham in Surrey, the station closest to their destination – Polesden Lacey, the home of The Hon. Mrs Ronald Greville. There the Duke and Duchess were able to escape from the public gaze.

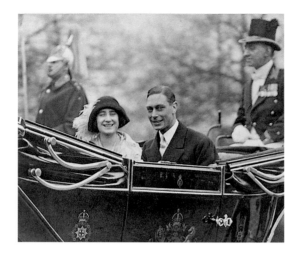

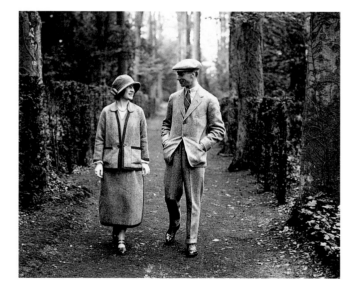

The day after the wedding the Duke of York wrote to Queen Mary to express his gratitude, and his happiness.

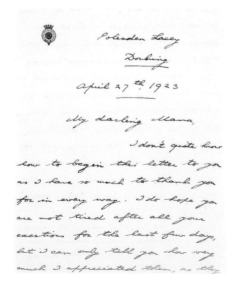

Polesden Lacey
Dorking
April 27th 1923

My darling Mama,

I don't quite know how to begin this letter to you as I have so much to thank you for in every way. I do hope you are not tired after all your exertions for the last few days, but I can only tell you how very much I appreciated them, as they

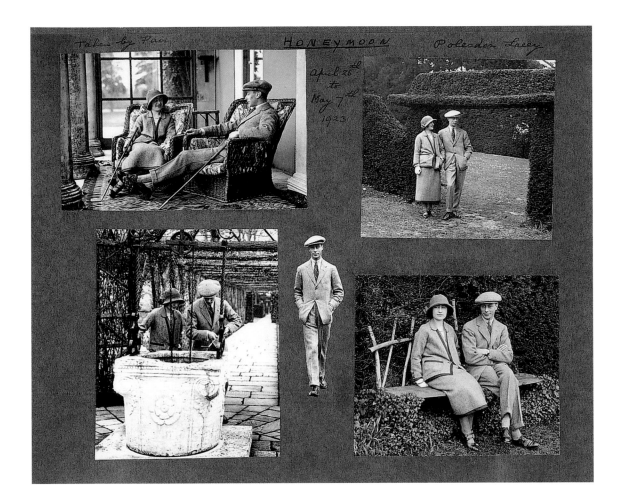

After the death of King George V and the abdication of King Edward VIII, in 1936 the Duke of York succeeded to the throne as King George VI and the Duchess became Queen Elizabeth. They celebrated their Silver Wedding anniversary in 1948, the year after the wedding of their elder daughter, Princess Elizabeth. King George VI died in 1952. His widow survived for another fifty years and died aged 101 in March 2002.

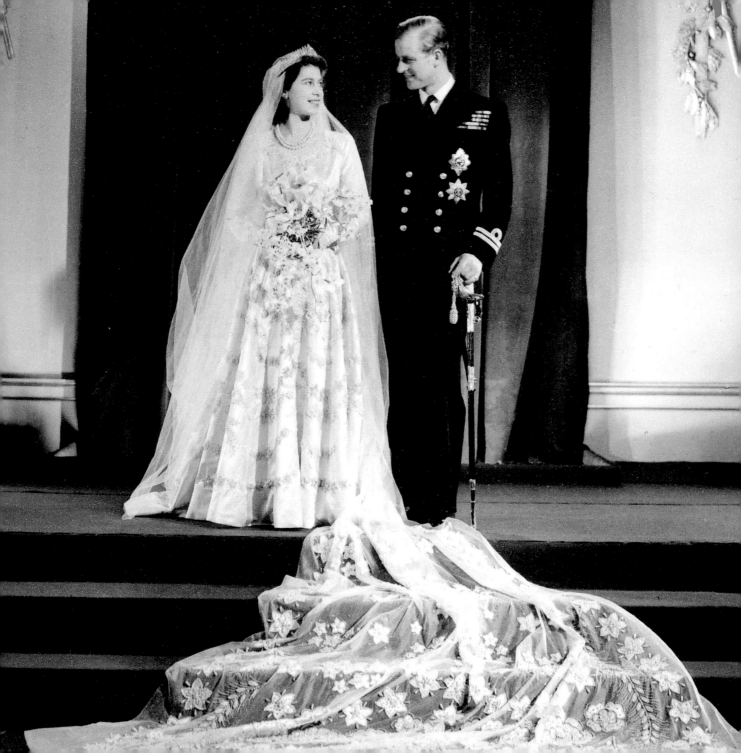

# ELIZABETH
## AND
# PHILIP

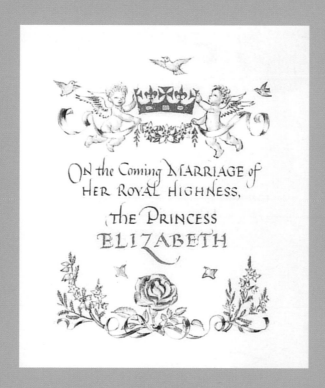

## 20 NOVEMBER 1947

Princess Elizabeth was born on 21 April 1926 at No. 17 Bruton Street, the London home of her maternal grandparents, the Earl and Countess of Strathmore. She was the elder child of the Duke and Duchess of York; her paternal grandparents were King George V and Queen Mary. As the second son, the Duke of York was not expected to become King.

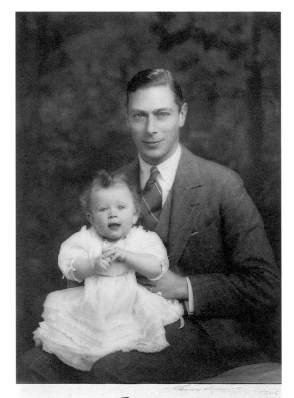

*Bertie*
*1926*

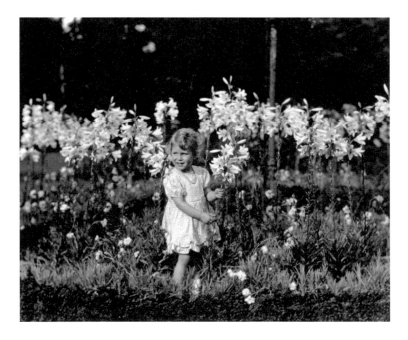

For Princess Elizabeth's first decade she led a relatively carefree life, within the Yorks' close and happy family circle. The photograph of the Princess among the lilies was taken by her father in 1929.

Following King Edward VIII's abdication and the accession of her father as King George VI in December 1936, the Princess was first in the line of succession to the throne. The group photograph shows the Royal Family immediately after the Coronation in 1937.

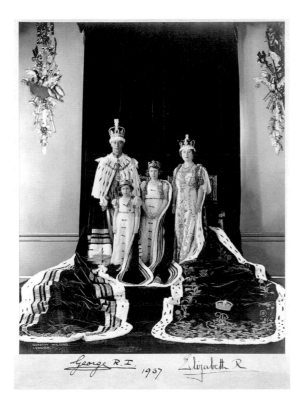

George R.I 1937  Elizabeth R

From the time of her eighteenth birthday Princess Elizabeth began to perform independent public duties. This photograph was taken in March 1947 in South Africa, where she celebrated her twenty-first birthday. On that occasion she pledged her life to the service of her people.

Prince Philip was born on 10 June 1921 at his family's home, Mon Repos, on the island of Corfu. He was the youngest child and only son of Prince and Princess Andrew of Greece. His mother, who was a great-granddaughter of Queen Victoria, was portrayed by De László in 1922.

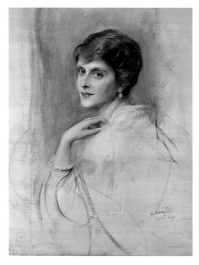

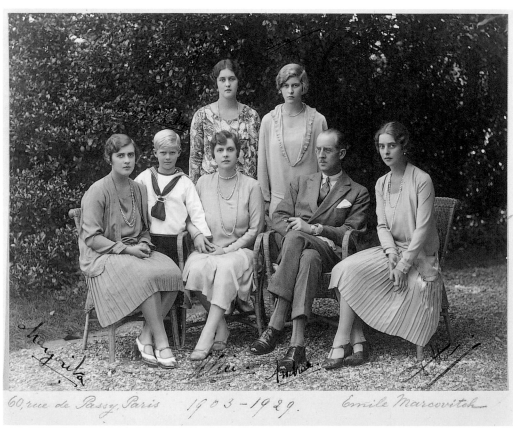

60, rue de Passy, Paris    1903 – 1929.    Emile Marcovitch

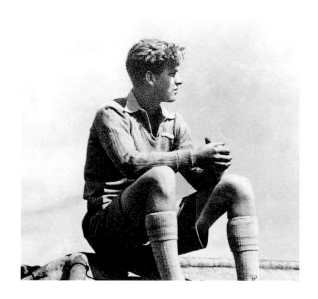

In May 1939 he commenced his studies at the Britannia Royal Naval College, Dartmouth, where he excelled. He saw active service in the war, rising from Midshipman to Lieutenant in 1942. In 1947 he was photographed making an inspection at HMS *Royal Arthur*, the petty officers' school at Corsham, Wiltshire.

When he was eighteen months old the Prince and his family left Greece and settled in exile in Paris, where the group photograph shown opposite was taken in 1929. Prince Philip was educated in Paris, Germany and Great Britain. The photograph above was taken during his school days at Gordonstoun.

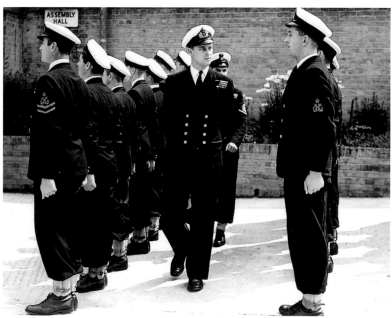

The close family connections between Princess Elizabeth and Prince Philip meant that they encountered each other on several occasions during their early years. However, their first publicised meeting was in July 1939 at Dartmouth, after which they were in regular contact.

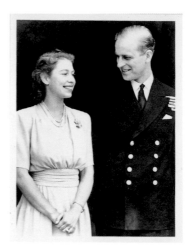

By the mid-1940s there was much media speculation about a romance. While Princess Elizabeth and her parents travelled to South Africa, in February 1947 Prince Philip renounced his Greek royal title and became a naturalised British subject with the surname of his maternal grandfather, Mountbatten. On 9 July 1947 the engagement was announced between Princess Elizabeth and Lieutenant Philip Mountbatten.

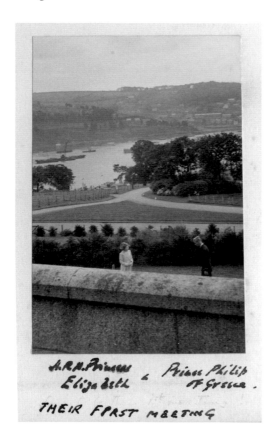

H.R.H. Princess Elizabeth & Prince Philip of Greece.
THEIR FIRST MEETING

### COURT CIRCULAR

BUCKINGHAM PALACE, July 9

It is with the greatest pleasure that The King and Queen announce the betrothal of their dearly beloved daughter The Princess Elizabeth to Lieutenant Philip Mountbatten, R.N., son of the late Prince Andrew of Greece and Princess Andrew (Princess Alice of Battenberg), to which union The King has gladly given his consent.

Betrothal of the Princess Elizabeth

The platinum and diamond engagement ring
was seen on the Princess's finger soon after.
A matching bracelet was a later
present from the bridegroom.

 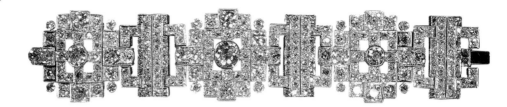

During their engagement a number of joint
duties were undertaken, including a visit to
Clydebank during which Princess Elizabeth
received the gift of a sewing machine.

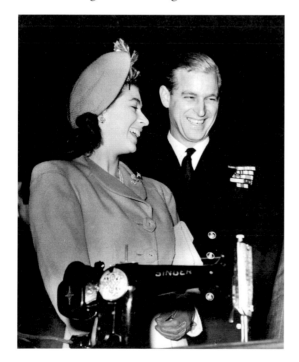

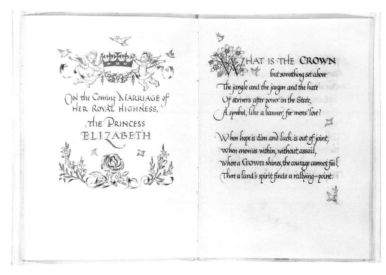

The Poet Laureate, John Masefield, wrote a
poem 'On the Coming Marriage'. The special
presentation copy for Princess Elizabeth was
beautifully inscribed on vellum.

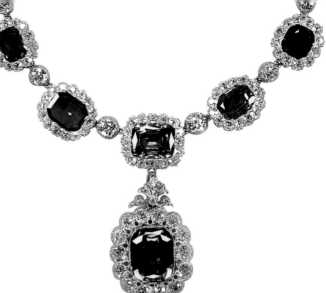

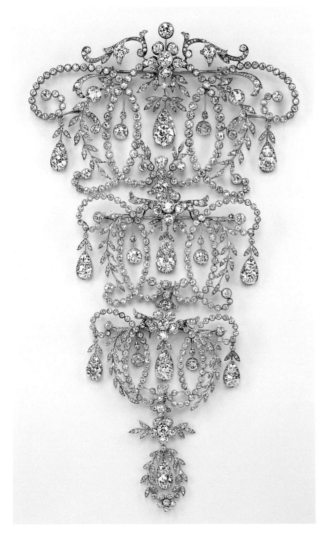

Princess Elizabeth received many pieces of jewellery at the time of her wedding. The diamond stomacher was part of Queen Mary's gift. Those from her parents included a sapphire and diamond suite and a pair of diamond chandelier earrings.

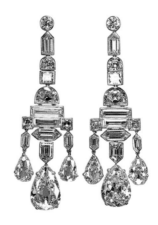

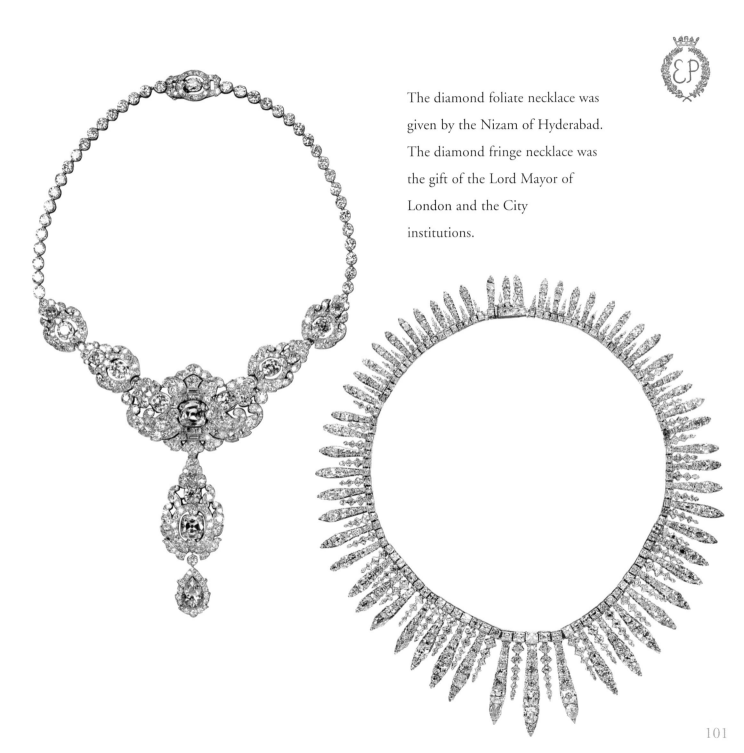

The diamond foliate necklace was given by the Nizam of Hyderabad. The diamond fringe necklace was the gift of the Lord Mayor of London and the City institutions.

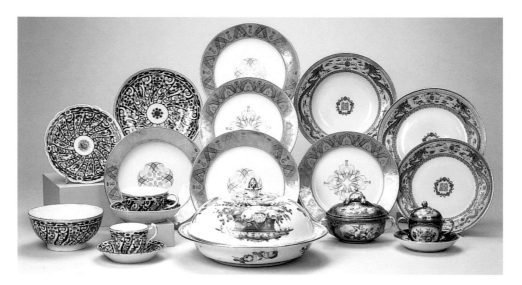

Other wedding presents had a more practical purpose. Several services of table china were received. The Royal Worcester dinner and dessert service (below) from the Brigade of Guards was decorated with the badges of each of the Guards regiments.

The presents illustrated above include on the right a Meissen chocolate pot and cover given by Pope Pius XII, and beside it to the left a Sèvres écuelle and cover given by Sir Kenneth and Lady Clark. Behind these are three pieces from a dinner service of Chinese porcelain given by the President of the Chinese Republic and Madame Chiang Kai-Shek. The five blue-rimmed plates are from the Sèvres service presented by the Government and People of France, and the Worcester pieces were given by Sir Arthur Penn. The Swansea tureen and cover in the centre foreground was presented by the Royal Welsh Agricultural Society.

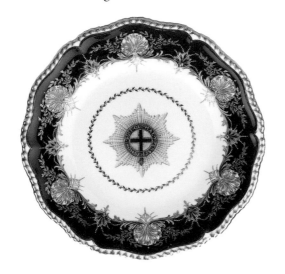

One of the wedding presents was this eighteenth-century French marriage fan, showing wedding guests wearing 'favours'. Among the more practical gifts were a Hoover vacuum-cleaner and an automatic potato peeler; also, an Anglepoise lamp, from members of the No. 1 M.T. training centre who had served with Princess Elizabeth in March and April 1945. All the wedding presents were placed on public display at St James's Palace.

A number of finely decorated pieces of ornamental glass were also received. This goblet was engraved by Laurence Whistler with a verse by Thomas Campion written for the marriage of an earlier Princess Elizabeth in 1613. The Steuben glass vase and cover, etched with the design of a merry-go-round, was the gift of the President of the United States and Mrs Truman.

The wedding dress was entrusted to Norman Hartnell, who had designed clothes for Queen Elizabeth since 1938. The dress was made of satin and decorated with 10,000 pearls, which Hartnell obtained from America. The 15 foot (4.6m) star-patterned train was woven in Braintree, Essex. The decoration was inspired by Botticelli's figure of Primavera – with the promise of rebirth and growth after the drabness of the war and its aftermath.

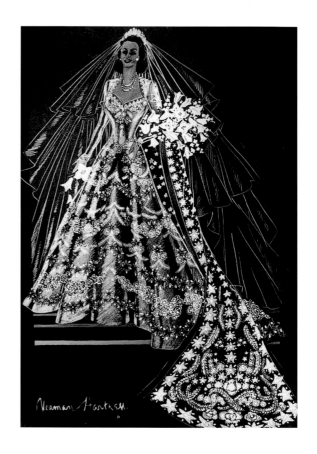

Princess Elizabeth's bouquet was made by Martin Longman of the Worshipful Company of Gardeners. It consisted of white orchids with a sprig of myrtle from the bush at Osborne. The bush was grown from a cutting brought from Coburg by Prince Albert. Sprigs from the bush have been included in the bouquets of all royal brides since the 1850s.

The veil was held in place by a diamond fringe tiara which was lent to Princess Elizabeth by the Queen, as 'something borrowed'. This incorporated diamonds from a necklace which had been a wedding present from Queen Victoria to Queen Mary, who gave the tiara to Queen Elizabeth in 1936.

Among the other jewels worn by the bride were two pearl necklaces (the Queen Anne and the Queen Caroline pearls) given by her parents, and pearl and diamond earrings which had belonged to one of George III's daughters; these had been a twentieth birthday present from Queen Mary to her granddaughter.

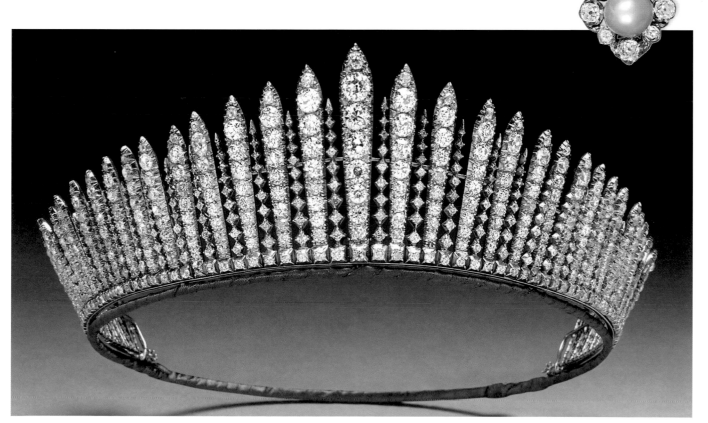

The wedding took place at Westminster
Abbey on 20 November 1947. Shortly before,
the bridegroom was named His Royal
Highness and created Duke of Edinburgh.
On 19 November he had been appointed a
Knight of the Garter; Princess Elizabeth had
been declared a Lady of the Order eight
days before.

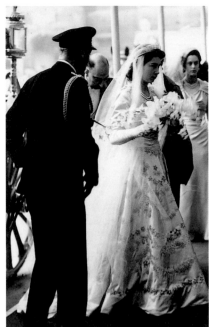

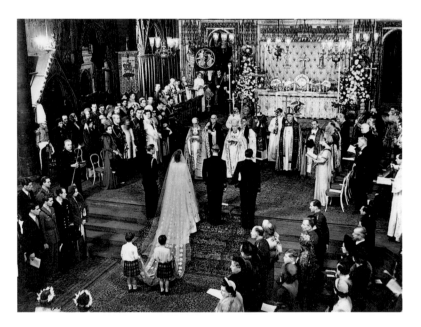

The bride drove with her father from
Buckingham Palace to Westminster Abbey in
the Irish State Coach. In this photograph
taken inside the Abbey the bride is shown
from behind, standing between her father
(who gave her away) and the bridegroom.
The groomsman was Prince Philip's cousin,
the Marquess of Milford Haven, and the
two small pages were Princess Elizabeth's
cousins Prince William of Gloucester and
Prince Michael of Kent. Queen Elizabeth
stands on the right of the main group.

A gold pen was presented to Princess Elizabeth by the Chartered Institute of Secretaries; it was to be used to sign the Marriage Register. The bride and groom, the bride's parents and grandmother (Queen Mary), the groom's mother and the Archbishop of Canterbury signed the register in the Abbey. The other signatures were entered later, at Buckingham Palace.

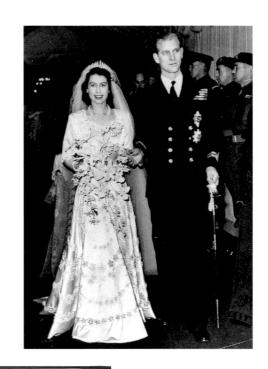

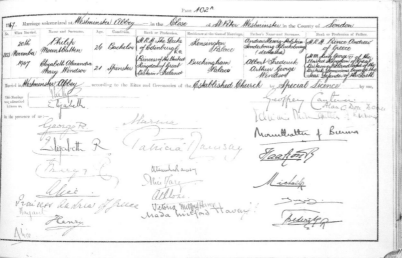

At the end of the service the radiant bride and groom emerged from the Abbey to great popular applause.

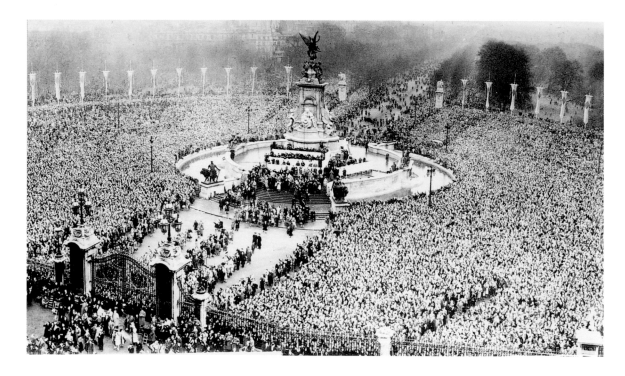

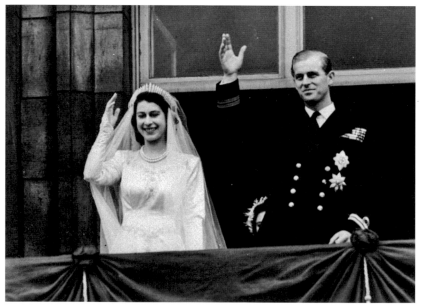

All along the processional route between the Abbey and Buckingham Palace the crowds were immense. After six years of war, the public seized the opportunity for celebration. At the Palace the bride and groom made many appearances on the balcony, to acknowledge the cheers from the crowds below.

The bridegroom wore naval uniform with his medal ribbons, the Stars of the Garter and of the Greek Order of the Redeemer.

Many formal photographs were taken in the Throne Room of Buckingham Palace. In the large family group Queen Victoria's granddaughter Princess Marie Louise sits in the right foreground while the dignified figure of Princess Andrew of Greece, the bridegroom's mother, stands second from the left. The eight bridesmaids and two pages, all relations or close friends of the bride, are also included in the group.

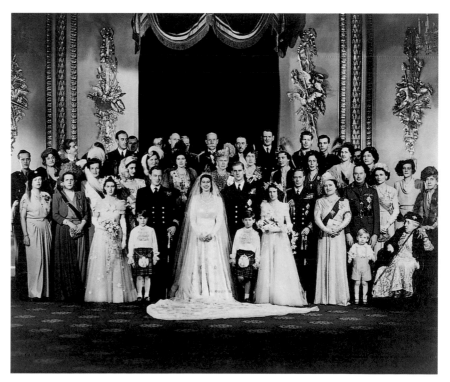

The Wedding Breakfast was served in the Ball Supper Room. Food rationing was still in force and the wedding cakes, shown here in a serried rank, were made from ingredients sent to the Princess from overseas. Pieces of cake, and food parcels containing surplus raw ingredients, were distributed throughout the United Kingdom. This silver-painted cake decoration – with hollow 'toe' to take a tiny bouquet – has survived from one of the wedding cakes.

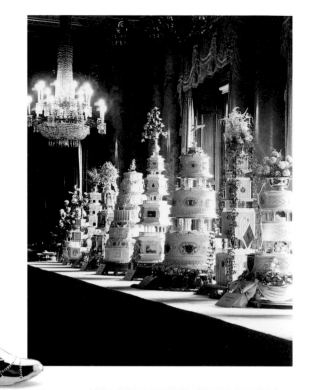

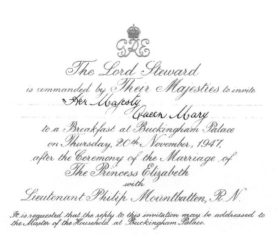

The Lord Steward
is commanded by Their Majesties to invite
Her Majesty
Queen Mary
to a Breakfast at Buckingham Palace
on Thursday, 20th November, 1947,
after the Ceremony of the Marriage of
The Princess Elizabeth
with
Lieutenant Philip Mountbatten, R.N.

It is requested that the reply to this invitation may be addressed to
the Master of the Household at Buckingham Palace.

BUCKINGHAM PALACE
THURSDAY, 20TH NOVEMBER, 1947
WEDDING BREAKFAST

Filet de Sole Mountbatten

———

Perdreau en Casserole
Haricots Verts    Pommes Noisette
Salade Royale

———

Bombe Glacée Princesse Elizabeth
Friandises

———

Dessert

———

Café

EP

The honeymoon was spent at Broadlands in Hampshire, the home of Prince Philip's uncle, Earl Mountbatten. A select group of press photographers were permitted to take photographs of the newly married couple.

Following the King's death in February 1952, Princess Elizabeth succeeded to the throne. The Queen and Prince Philip's four children – three boys and one girl – were born between 1948 and 1964. In November 2007 Her Majesty and His Royal Highness will celebrate their Diamond Wedding anniversary. The Queen is the first reigning Sovereign to reach this anniversary.

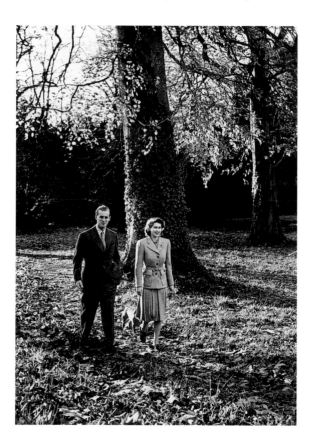

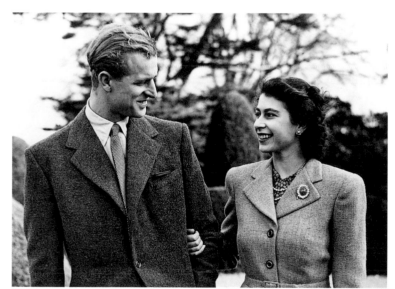

# Music from five Royal Weddings

## Queen Victoria and Prince Albert

Chapel Royal, St James's Palace

10 February 1840

The National Anthem

Psalm LXVII (God be merciful unto us)   *Kent*

Blessed be the Lord God   *King*

Deus Misereatur, in B flat   *King*

---

## Albert Edward, Prince of Wales and Princess Alexandra of Denmark

St George's Chapel, Windsor Castle

10 March 1863

### Before the service

Triumphal March   *Beethoven*

March from 'Athalie'   *Mendelssohn*

March from 'Joseph'   *Handel*

### During the service

Chorale: This Day, with Joyful Heart
and Voice (T. Oliphant)   *The Prince Consort*

Psalm LXVII (God be merciful unto us)

Hallelujah Chorus from
'The Mount of Olives'   *Beethoven*

## The Duke of York and Princess Victoria Mary of Teck

Chapel Royal, St James's Palace

6 July 1893

### Before the service

March (Occasional)   *Handel*

March from 'Scipio'   *Handel*

Imperial March   *Sullivan*

March in G   *H. Smart*

Bridal March from 'Löhengrin'   *Wagner*

### During the service

Chorale: Father of Life (Rev. S. Flood Jones)   *Cresser*

Psalm LXVII (God be merciful unto us)   *Goss*

Anthem: O Perfect Love   *Barnby*

Hymn: Lead us, Heavenly Father   *'Mannheim'*

### Procession

Wedding March   *Mendelssohn*

<div style="display: flex;">
<div style="flex: 1;">

## The Duke of York and Lady Elizabeth Bowes Lyon

Westminster Abbey

26 April 1923

### Before the service

Suite *Purcell*

Andante and Finale from
Sonata in C# Minor *Basil Harwood*

Minuet from 'Berenice' *Handel*

Benediction Nuptiale *Saint-Saëns*

Imperial March *Elgar*

Bridal March *Parry*

### During the service

Hymn: Lead us, Heavenly Father *'Mannheim'*

Psalm LXVII (God be merciful unto us) *S. Wesley*

Hymn: Praise, my soul, the King of Heaven *Sir J. Goss*

Amen *Orlando Gibbons*

The National Anthem

Anthem
(during the signing of the register) *Sydney H. Nicholson*

### Procession

Wedding March *Mendelssohn*

Marcia Eroica *Stanford*

</div>
<div style="flex: 1;">

## Princess Elizabeth and The Duke of Edinburgh

Westminster Abbey

20 November 1947

### Before the service

Sonata in G Major (1st movement) *Elgar*

Andante Cantabile *Widor*

Fugue Alla Giga *Bach*

Jesu, Joy of Man's Desiring *Bach*

Selections from 'The Water Music' *Handel*

Bridal March and Finale *Parry*

### During the service

Hymn:
Praise my soul, the King of Heaven *Henry Lyte*

Psalm LXVII
(God be merciful unto us) *E.C. Bairstow*

Anthem:
We wait for thy loving kindness O God *William Mckie*

Hymn:
The Lord's my shepherd, I'll not want *Crimond*

Amen *Orlando Gibbons*

Anthem: Blessed be the God and
Father of our Lord Jesus Christ *Samuel S. Wesley*

### Procession

Wedding March *Mendelssohn*

</div>
</div>

# Illustrations

Unless otherwise stated, all illustrations are The Royal Collection © 2007, HM Queen Elizabeth II. Items with RA references are: The Royal Archives © 2007, HM Queen Elizabeth II. Royal Collection Enterprises are grateful for permission to reproduce those items listed below for which copyright is not held by the Royal Collection or the Royal Archives.

The quotations from Queen Victoria's Journal on pp. 14, 16, 19, 21, 23, 24, 26 and 28 are from RA VIC/QVJ/Esher. The quotation on p. 37 is from Frances Dimond, *Developing the Picture: Queen Alexandra and the art of Photography*, London, 2004, p. 19; those on pp. 65 and 68 are from James Pope-Hennessy, *Queen Mary 1867-1953*, London, 1959, p. 268; and that on p. 79 is from Susan Owens, *Watercolours and Drawings from the Collection of Queen Elizabeth The Queen Mother*, London, 2005, p. 66.

## Introduction

### p. 3
• Gold finger ring with conjoined ruby and diamond hearts, 1840 (RCIN 14635)

### p. 4
• Gold bracelet with jewelled letters V and M, made to celebrate the marriage of Princess Victoria Mary of Teck and the Duke of York, 1893 (RCIN 65679)

### p. 5
• Front cover of the Royal Marriage Register for the Chapel Royal, St James's Palace. Photograph: The Royal Collection © 2007, HM Queen Elizabeth II. Reproduction with permission of the Dean of the Chapels Royal

### p. 6
• Queen Victoria's gold and porcelain orange blossom headband, made to the designs of Prince Albert, 1846 (RCIN 65305)
• Menu for the Wedding Breakfast at Buckingham Palace, 6 July 1893 (RA F&V/Weddings/1893/GV: wedding breakfast menu)

## Victoria and Albert, 10 February 1840

### p. 8
• Sir George Hayter, *The Marriage of Queen Victoria and Prince Albert, 10 February 1840*, 1840-42 (detail; oil on canvas; RCIN 407165)

### p. 9
• Victoria, Crown Princess of Prussia, *Ornamental design for a plaque on the Prince Albert cabinet*, 1861 (detail; watercolour; RCIN 451130)

### p. 10
• William Westall, *Kensington Palace: the south and east fronts*, 1819 (watercolour; RCIN 922148)
• Sir William Beechey, *Victoria, Duchess of Kent, and Princess Victoria*, 1821 (oil on canvas; RCIN 407169)

### p. 11
• Sir Edwin Landseer, *Dash*, 1836 (oil on canvas; RCIN 403096)
• Sir David Wilkie, *Queen Victoria at her Accession Council*, 1837 (watercolour; RCIN 913590)

### p. 12
• Prince Albert's first shoes of green satin, and chased gilt metal box containing a lock of his hair, with explanatory note in Queen Victoria's hand (RCIN 55341.a-c, e)
• Heinrich Justus Schneider, *The Rosenau, Coburg, from Wohlsbacher Grund*, 1845 (watercolour; RCIN 920428)
• Georg Rothbart, *The Rosenau: the room used by Princes Ernest and Albert as children*, c.1845 (watercolour; RCIN 920468)

### p. 13
• Magdalena Dalton after Ludwig Döll, *Princes Albert and Ernest of Saxe-Coburg and Gotha in 1829*, c.1846 (watercolour; RCIN 912109)
• Letter from Prince Albert to Queen Victoria, 26 June 1837 (RA VIC/Z 296/8)

### p. 14
• *'Leap Year'*, 1840 (lithograph; RCIN 605764)
• Sir William Ross, *Queen Victoria*, 1840 (watercolour on ivory; RCIN 422422)
• Sir William Ross, *Prince Albert*, 1839-40 (watercolour on ivory; RCIN 421462)

### p. 15
• Text of Queen Victoria's announcement to the Privy Council of her engagement to Prince Albert, 23 November 1839 (RA VIC/A 85/46)
• Gold bracelet with conjoined amethyst hearts, 1839 (RCIN 65296)

### p. 16
• Gold and porcelain orange blossom brooch, made to the designs of Prince Albert, 1839 (RCIN 65306.1a)
• Prince Albert, *Dem Fernen*, 1839 (RCIN 1140987)
• Prince Albert, *Der Orangenzweig*, 1839 (RCIN 1140982)

### p. 17
• New Year token, enclosed with a letter from Prince Albert to Queen Victoria, 28 December 1839 (RA VIC/Z 296/41 (token))
• Baton fan with blackamoor finials, c.1750 (RCIN 25091)

### p. 18
• Prince Albert's Garter, made by Rundell, Bridge & Co., 1840 (RCIN 441143)
• Gold bookmark with gemstones (Vermeil, Jargoon, Chrysolite, Turquoise, Opal, Ruby, Jargoon, Amethyst) on silk ribbons, 1840 (RCIN 98141)
• *The Form of Morning Prayer*, edited by Charlotte Grimston and published by J. Hatchard, 1837; in velvet binding 1840 (RCIN 1129966)

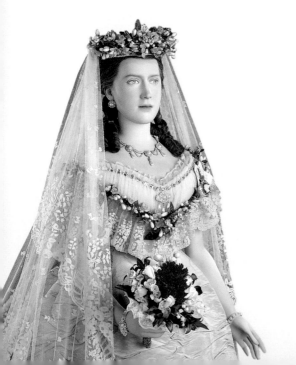

## Victoria Mary and George, 6 July 1893

p. 56
• *Composite engagement photograph of the Duke of York and Princess Victoria Mary of Teck, May 1893* (RCIN 2925830): photograph by Russell & Sons
• Diary entry of the Duke of York for 3 May 1893 (RA GV/GVD/1893: 3 May)
• Telegram from the Duke of York to Queen Victoria requesting her consent to his marriage, 3 May 1893; annotated with the Queen's reply (RA VIC/Z 476/30-31)

p. 57
• Arthur Hopkins, *Princess Victoria Mary of Teck with her mother, choosing her wedding trousseau, May 1893* (pencil, ink, white heightening; RCIN 920837)
• Letter from Princess Victoria Mary of Teck to the Duke of York, 20 June 1893 (RA GV/CC 5/15)

p. 58
• Tea gowns, morning robes, etc., from *The Gentlewoman's 'Royal Record of the wedding of H.S.H. The Princess Victoria Mary of Teck and H.R.H. The Duke of York, July 6 1893'* (RCIN 1055747, p. 25)
• Silk sachet trimmed with ostrich feathers and wax orange blossom (RCIN 120035)

p. 59
• *Mr Seurey's wedding cake, at the garden party at White Lodge, July 1893* (RCIN 2300455)
• Menu for dinner at Buckingham Palace, 5 July 1893 (RA F&V/Weddings/1893/GV: menu card for dinner, 5 July 1893)

p. 60
• *Princess Victoria Mary's wedding presents at White Lodge, Richmond, July 1893* (RCIN 2300452)
• Letter from the Duke of York to Princess Victoria Mary of Teck, 3 July 1893 (RA GV/CC 1/26)

p. 61
• *Descriptive Catalogue of the Wedding Gifts to H.R.H. The Duke of York K.G. and H.S.H. The Princess May of Teck*, exh. cat., Imperial Institute, London, 1893 (RA F&V/Weddings/1893/GV: wedding present list)
• Arthur Kemp Tebby, *Visitors examining the wedding presents on display at the Imperial Institute*, 1893 (ink, with touches of blue crayon; RCIN 920849)
• Pair of diamond-studded gold opera glasses, made by Tiffany & Co., c.1890 (RCIN 9027)

p. 62
• Irish (Youghal) lace fan, 1893 (RCIN 25131)
• 'La Fontaine de Jouvence' fan, c.1890 (RCIN 25138)
• 'Jacob meeting Rachel at the well' fan, c.1750 (RCIN 25362)
• Honiton lace fan, 1893 (RCIN 25398)

p. 63
• 'Girls of Great Britain' diamond tiara, made by Garrards, 1893; altered 1914, 1969 (RCIN 200192)
• County of Cornwall ruby and diamond bracelet, 1893 (RCIN 200144)
• Kensington bow brooch, made by Collingwood & Co., ?1893 (RCIN 200196)
• Dorset bow brooch, made by Carrington & Co., 1893 (RCIN 200190)

p. 64
• Ceremonial for the royal marriage ceremony, Chapel Royal, St James's Palace, 6 July 1893 (RA F&V/Weddings/1893/GV: ceremonial)
• Invitations to the marriage ceremony, and the Wedding Breakfast, 6 July 1893 (RA F&V/Weddings/1893/GV: invitations)
• Diary entry of the Duke of York for 6 July 1893 (RA GV/GVD/1893: 6 July)

p. 65
• Marriage licence of the Duke of York and Princess Victoria Mary of Teck, 1893 (Chapel Royal, St James's Palace). Photograph: The Royal Collection © 2007, HM Queen Elizabeth II. Reproduced with permission of the Dean of the Chapels Royal
• Wedding favour, with explanatory note, distributed to children by Baroness Burdett-Coutts, 1893 (RCIN 55068)
• Laurits Tuxen, *The marriage of the Duke of York and Princess Victoria Mary of Teck, 6 July 1893* (oil on canvas; RCIN 402437)

p. 66
• Wedding photograph of the Duke and Duchess of York, 6 July 1893, in ornamental frame (RCIN 120030)
• *The wedding dress of Princess Victoria Mary of Teck, 1893*. Topfoto

p. 67
• Princess Victoria Mary's Honiton lace handkerchief, 1893 (RCIN 120026)
• Princess Victoria Mary's silk wedding stockings, 1893 (RCIN 120028.a-b)

p. 68
• 'Rose of York' diamond and enamel brooch (centrepiece from a bracelet), made by Messrs Collingwood & Co., 1893 (RCIN 45549)
• *The Duke and Duchess of York with their bridesmaids, 6 July 1893* (RCIN 2870062): photograph by Lafayette

p. 69
• Menu for the Wedding Breakfast for the Duke and Duchess of York, 6 July 1893 (RA F&V/Weddings/1893/GV: wedding breakfast menu)
• *The wedding cakes*, and *The State Dining Room prepared for the Royal Wedding Breakfast, 6 July 1893* (RA F&V/Weddings/1893/GV: newspaper cuttings)

p. 70
• The Duchess of York's going-away dress, made by Redfern, 1893 (RCIN 72018.a-b): photograph by Historic Royal Palaces: The Royal Collection © 2007, HM Queen Elizabeth II
• The Duchess of York's going-away shoes, made by C. Moykopf, 1893 (RCIN 72019.1-2)

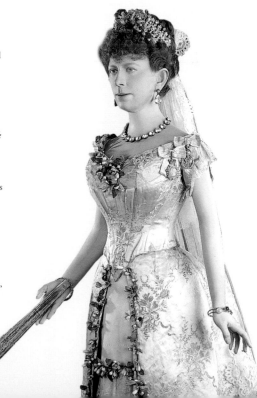

## Elizabeth and Albert, 26 April 1923

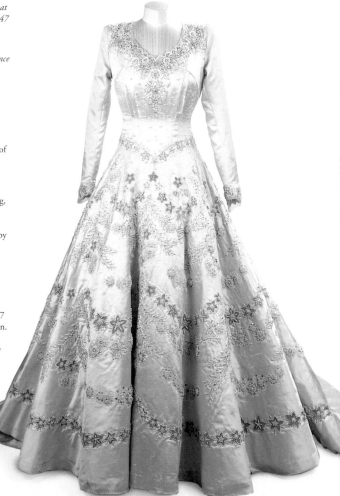

## Music

## Illustrations

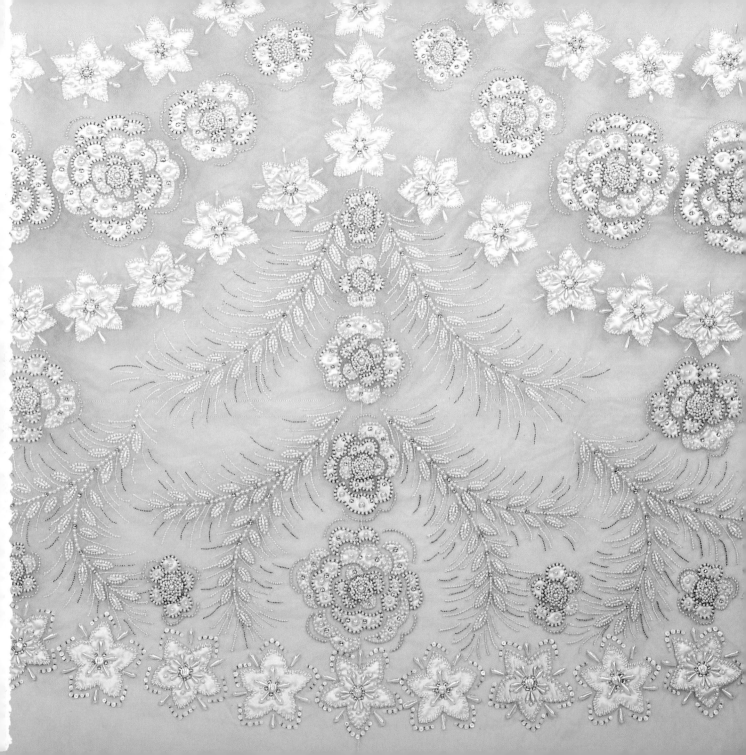